Harness the power of color. Change your life.
COLOR SMART

It's no secret that colors reflect—and directly *affect*—our moods and emotions. The secret lies in the *whys* and *hows* of color's impact. Different colors send particular signals, some simple and some complex. Whether these signals are stimulating or soothing, enticing or repellent, we invariably respond in kind. *Daring crimsons and dignified violets. Contemplative blues and glorious yellows. Delicate, chalky pinks and rich, earthy browns.* Call it the science of color. It's what the world's savviest retailers and marketers have been doing for years. And they rely on color expert Mimi Cooper to help them make the most of it.

Now Cooper makes color theory available to everyone, applying it to all areas of life and work, including:

- how to use color to communicate with potential lovers, employers, and friends

- how to decorate a "power office"

- what color sells a car the fastest

COLOR SMART brings together all the research, expertise, and insider tips you need to harness the astonishing power of color.

Color Smart

How to Use Color to Enhance
Your Business and Personal Life

MIMI COOPER
WITH ARLENE MATTHEWS

POCKET BOOKS
NEW YORK LONDON TORONTO SYDNEY SINGAPORE

An *Original* Publication of POCKET BOOKS

 POCKET BOOKS, a division of Simon & Schuster Inc.
1230 Avenue of the Americas, New York, NY 10020

ISBN: 0-671-03459-6

First Pocket Books trade paperback printing July 2000

10 9 8 7 6 5 4 3 2 1

POCKET and colophon are registered trademarks of Simon & Schuster Inc.

Designed by Joseph Rutt

Printed in the U.S.A.

This book is dedicated to my husband, Bob,
who loves new challenges and
always runs down the halls with me.

ACKNOWLEDGMENTS

Color is a complicated issue. Working to make it simple required input from many people, who contributed their expertise or experiences. The following people made this book possible by contributing information and by educating me on color:

Chuck Henebry
Nancy Goroff
Nancy Johnson
Noriko Goroff
Anna Whitney
Dan Goroff
Pam Baukus
Kenneth Charbonneau
Jane Stockel
Marilyn Rantz
French American
 Trade Commission
University of Illinois at
 Chicago Health
 Sciences Librarians

Anne Marie Starr
Rupert Wenzel
Marcia Ganczewski
Sarah Snyder
Jodie Kalikow
Gottfried Pank
Karen Reuther
Steve Toth
Marilyn White
Lynn Scheir
Gary Uhl
Lee Manus

CONTENTS

The Importance of Color
An Introduction

The astonishing power of color is in evidence everywhere. To take a walk in the woods is to observe how Mother Nature uses color to further mating and procreation, be it in peacocks, butterflies, or sunflowers. To saunter through a cocktail party is to notice how a young lady in a crimson dress uses it for . . . well, much the same purpose.

But now take a walk through a supermarket, department store, hardware store, airport, brokerage office, or anywhere products and services are offered. Did you know color is used to sell us not just on love but on lingerie and linens, laundry detergent and light bulbs (soft pink wattage, anyone?), and even stocks and mutual funds (ever notice the carefully chosen colors on a corporate report or fund prospectus?).

Color sends signals both subtle and complex, and

we respond to its messages viscerally. Color can be arresting, stimulating, soothing or jarring, enticing or incendiary.

For the past twenty years, my company, the Cooper Marketing Group Inc., has researched how color is used to influence people's perceptions, ideas, and habits. We have shared our knowledge with Fortune 500 companies in fields as diverse as communications, clothing, home furnishings, automobiles, foods and beverages, and even toys. In any given week, our annual Cooper Color Report has been employed to accomplish such diverse goals as coloring a candy "delectable," a perfume bottle "irresistible," or a cellular phone "dynamic."

Why is this such valuable information? Because color is critical to the choices we all make, and because we live in a world with more color options than ever before. In 1856, William Perkins, an English chemist, created the first analine dye, called analine purple—we now know it as mauve. Adolpf von Baeyer, a German chemist and winner of the Nobel Prize in 1905, went on to create more dyes. This was the beginning of our ability to create man-made dyes, and therefore, to have products in a myriad of colors. More recently, technology has advanced, allowing us to have metallics, pearlescents, and a host of textured

looks. Now nearly anything you can think of comes in almost any color.

Color Smart gives you the color secrets we've learned over the past two decades—the principles underlying the role of color in our lives—so that each of us can be Color Smart.

Armed with the Color Smart principles, you will be able to determine the individual color preferences of anyone with whom you will be interacting. You will understand the universal meanings of colors. And you'll be able to select the most effective colors for any item or occasion.

You'll learn how businesses and manufacturers use color to influence what you buy, and how you can turn the tables and employ color to sell anything at all—from yourself on a job interview or sales call, to your house above market, to old clothes at a yard sale.

Because color can help you communicate with anyone, you'll also learn about cross-generational and cross-cultural uses of color. You'll see how kids use color in ways different from adults, and how people in other countries use color in ways different from Americans. Lastly, you'll learn about the future of color in a technology-driven world, where methods of using color are virtually limitless.

Up until now color may have been one of those

things you simply took for granted. But have you ever thought about what it would be like to live in a world with no color at all?

While we were writing this book we watched a delightful movie called *Pleasantville*. In it, a teenage boy and girl are transported to a 50's style "sitcom" town, where everything—and everyone—is black and white and gray. The visitors soon learn that as color is lacking, so are people's emotions, dreams, and passions. But as real inner feeling grows in the townsfolk, color blossoms forth. A rose dares to bloom brilliant red; lips and tongues turn intriguingly pink; cars, clothes, books, houses, and lawns take on sparkling shades. And as more and more color is added, so is more zest, more vibrancy, more vitality.

We also came across a wonderful Mexican folk-tale, recounted in a children's book called *The Story of Colors*. The tale has it that the world was once black and white except for the gray of dusk and dawn "so that the black and white didn't bump into each other so hard." Then the gods decided to create color to "make the world more joyous for men and women." And so they climbed to the top of a ceiba tree and flung the colors wildly about. Nothing, of course, was ever the same.

What do the filmmaker and the tale-teller know?

What we all know, but perhaps haven't thought much about—until now: Color is the ultimate natural resource. Without it, life would be monotonous and the world uninspiring. With it, anything is possible.

And this is especially true when one is Color Smart.

Color
Smart

Becoming Color Smart
Understanding Color Profiles

I've been a marketing consultant for over twenty years. When I started helping my clients to use color in their products I knew very little, but I made a lot of assumptions:

1. Fashionable (new) colors are first tried by the rich and by young, urban professionals.

2. From them the colors trickle down to the rest of us.

3. New colors are determined by a few powerful designers somewhere—maybe Paris—and the rest of us are forced to follow along.

4. Blue is the most popular color.

Well, I wasn't wrong about everything. Blue is the most popular. But otherwise, I had a lot to learn.

In the real world, the yuppies are too busy and the rich too conservative to experiment with the newest colors. And new colors don't just come from a few high-profile designers. Besides, if the rest of us don't like the new colors, they fail.

So who really tries new colors first? And what are other people doing about color?

After a great deal of research, we saw unquestionably that there are three distinct color personalities. We named and trademarked these three color personality profiles as Color-Forward®, Color-Prudent®, and Color-Loyal.®

Understanding these three personalities—in terms of what they signify and who tends to fit into their profiles—will be your first step toward becoming Color Smart. However, if you're like most people, the first thing you want to know is: Which one do I fit into?

So before we tell you what traits members of each of these three groups tend to exhibit (and therefore perhaps influence your evaluation of which one you think you'd *like* to be), we offer this simple self test to see with what type you will "cluster."

First simply check off all the following statements

with which you agree. And if you strongly agree with a statement, give it two checks. For now, just ignore the letters in parentheses that follow them. There are no "right" or "wrong" answers. It's all a matter of opinion. As you are answering, think about your recent color choices—a dress, a shirt, a tie, an automobile, place mats, upholstery, or carpeting.

- I will pay more for new, fashionable colors in clothing. (A)

- I usually buy new colors/products after my friends have tried them. (B)

- I buy products in colors that are practical, rather than stylish. (C).

- I have to see a color several times before I get used to it. (B)

- I feel good when I buy something in a new color for myself. (A)

- I rarely try a new color unless someone else suggests it. (C)

- I think the new colors in clothing do not look as good on me as the colors I usually wear. (C)

- I am a middle-of-the-road person in choosing colors—some new and some old favorites. (B)

- I would rather buy something in a new, fashionable color than replace something with the same color. (A)

- I am excited to see the new colors of the season. (A)

- I do not have time to figure out how to add a new color to my wardrobe. (B)

- I like basic, traditional colors. (C)

- Shopping would be better if there were fewer changes in color from year to year. (C)

- I like to be considered a leader when it comes to buying new products on the market. (A)

- I am too practical to try a new color the first time I see it. (B)

- I am not the first person to try new colors, but I will try them when I have seen them a few times. (B)

- I like to learn about the newest fashionable colors from magazines, salespeople, store displays, etc. (A)

- I will buy fashionable colors only if I think they are not a fad. (C)

Now just count up your *total* number of check marks (doubles for "strongly agree" count as two), and see whether you have more A's, B's or C's.

If you scored more A's, you are what we call Color-Forward; more B's and you are Color-Prudent; more C's, Color-Loyal. You'll undoubtedly recognize yourself in the section below that defines your group's predominant characteristics.

We understand if you want to sneak a peek ahead in the text to locate yourself and your kindred color spirits—but do be sure to read all three profiles. After we describe them, we will explain how you can use them to your greatest advantage in your personal and professional life.

BEING COLOR-FORWARD

Every year, these people can't wait to see the new colors for fall; they can't wait to see the new colors for

spring. They want to do more than view these colors out of curiosity. They long to embrace them and make them their own.

Color-Forward women love to peruse store displays for the latest color trends. You'll usually find them wearing the latest "in" shades. And they don't necessarily care if the new colors don't go with everything else they have. They're willing to spend more on a wardrobe to keep it "color current."

Color-Forward men are intrigued by new colors for cars, trucks, and SUVs, and you'll often find them driving a vehicle in a color none of their pals has yet tried. (This is the sort of guy who was big, for example, on the Ford Mustang iridescent "mood-ring" color that looked purplish from one angle and bluish/teal from another.

No self-respecting Color-Forwards would ever consider redecorating their home in colors they'd previously tried. And when they buy a new house, the first thing they do is repaint and recarpet in new colors. Their home furnishings tend to be contemporary, and they enjoy using their homes, like their clothing and their automobiles, to make bold and exciting statements. They often try more than one new color at a time, experimenting with daring combinations. They are the people that would cheerfully have paid

$200 more for the colored iMac computer when it made its debut.

From a psychological perspective, Color-Forwards tend to evince personality traits of self-confidence, adventurousness, and enthusiasm. They are less afraid than the average bear when it comes to going out on a limb and taking risks. And as you may have suspected, they are not put off by change, but tend to welcome it.

From an economic perspective, it is Color-Forwards who drive consumer markets. They spend a lot on themselves, and feel they're worth it.

Demographically (for demographics are still part of the equation), Color-Forwards make up about 20 percent of the population. More women than men are Color-Forward, and Hispanics and African Americans are more likely to be Color Forward.

Interestingly, this category tends to contain two disparate age groups. First, there are the teens through thirtysomethings, who pride themselves on having an up-to-the-minute sense of style. One might well expect them to be Color-Forward. However, they are often joined by another set—women and men in the forty-five to sixty-five age bracket whose kids have grown, who have more disposable income, and who use splashes of new color to feel youthful and invigo-

rated. For them, the goal of being "cool" or trendy is what we call a revisited value.

If you live in a city in the Southwest or the Mid-Atlantic States, you are statistically more liable to be Color-Forward. But Color-Forwards can, and do, pop up everywhere.

BEING COLOR-PRUDENT

Don't be surprised if you feel most comfortable in this category, for it is where half of us fall. Color-Prudents are somewhat cautious when it comes to color choice. They want to feel secure in the knowledge that new colors will be around for more than one fleeting season, that big-ticket items in new shades will retain their resale value, and that they won't quickly grow tired of what they buy.

True, they're not trying to be on the cutting edge of color fashion, but they do believe color adds zip to life and they are interested in what's up and coming. They pay attention to store displays and catalogs to see what colors have staying power.

On a given day, you might find them dressed in the same color as a Color-Forward friend, but odds are high that they would have added that color to their wardrobe months later, after others had tested

the waters. And often, when they try a new color, they try it in a small dose at first, perhaps as an accessory, and in combination with a trusty old color they are used to.

Color-Prudents are not resistant to change, but they do not make change for its own sake. They are informed and pragmatic and want to know that whatever changes they make will prove functional and useful for some time to come. They are also attentive and will distinguish and seek out, for example, softer shades within a color.

Being impulsive is not among the personality traits of the Color-Prudent type. But neither are these people sticks in the mud. Though involved in lots of other things, they enjoy the idea of updating a wardrobe or home now and again.

Demographically, men and women comprise equal halves of Color-Prudents. And this group falls mostly in the middle-income range.

BEING COLOR-LOYAL

The only way a Color-Loyal sort of person is likely to try a new color is—not to put too fine a point on it—kicking and screaming. For this group, traditional values are the be-all and end-all.

Usually Color-Loyals are comfortable with consistency in colors and don't plan on changing. These people have found what they like and what works for them, and they stick with it. If their navy windbreakers have seen better days, they'll replace them with new navy windbreakers (and if they can't find the same shade, they'll whine about it.) They are stalwarts who like what they like, and believe new stuff never looks as good on them as their old stuff. Even if they have a fashion flair, they don't give a fig for the trends of the moment.

Think of men in navy blazers, charcoal gray pants, light blue or white shirts, and ties with perhaps a bit of red in small, tasteful patterns. Think of women in black (they wouldn't have worn this color ten years ago, when it was considered cutting edge, but they will now since black has evolved into mainstream "safe"). Now picture them all sitting on dark brown couches in homes that are furnished in either country/casual or traditional/formal. And imagine them driving black automobiles. These are your classic Color-Loyals.

Of course, this description may lead you to think that Color-Loyals tend to be older and "stuffier" than the average person. But, interestingly enough, that would be a false preconception. Among the most

tried-and-true Color-Loyals are extremely busy, some-times overtaxed people (e.g., young urban profession-als or working mothers with young children) who sim-ply have little time or patience for the "luxury" of sampling colors that don't coordinate with everything else they own.

Demographically, the income of older Color-Loyals is significantly lower than the other two groups. Men in this group outnumber women two to one, and they tend to be older.

OF RARE EXCEPTIONS AND SWEATSUITS IN CHARTREUSE

Color personalities are highly relevant to nearly every decision each of us makes about what to buy, what to wear, what to drive, and what to surround ourselves with.

Naturally there are times when all of us may step outside the confines of our preferred color personality (few of even the most Color-Forward among us wants a magenta sofa, and any of us might pick a beige car-pet because it works well in a large area), but, by and large, we stay within the realm of our profile and choose from its color palette.

In fact, when someone makes a choice outside

what is generally their customary norm, the rest of us notice.

We knew a middle-aged gentleman named Jim, for example, a down-to-earth, plain-living sort who generally dressed in unremarkable colors. But one day he showed up at a casual social event in the brightest of bright chartreuse sweatsuits. (Chartreuse was a color that had briefly been in vogue the previous season.) Everyone noticed, to say the least. We even heard a friend of ours comment that he looked like a "squished caterpillar."

The brightly clad gentleman, however, maintained that this was the most comfortable piece of clothing he'd ever come across—and he couldn't understand why it had been on sale for only ten dollars.

Finally, one of his cronies could stand it no longer.

"Jim, are you color-blind?" he asked, flabbergasted.

"Why, yes," replied Jim. "As a matter of fact, I am."

KNOWLEDGE IS POWER

So what do these color personalities mean in terms of your becoming Color Smart?

The answer is they mean a great deal.

Manufacturers have known for quite some time that colors can be used to influence people's decisions and behaviors, likes and dislikes. Understanding how color influences people can give us an advantage in all our dealings.

You see, on one level, people gravitate toward one palette or another because a certain range of colors represents how they see themselves and where they feel most secure. But, on another level, they react to other people based in part on whether or not the palettes of those other people provide them with a level of comfort or not.

Now you might think, okay, that's simple enough. If I want someone to relate to me well I should choose colors from their palette of choice when I interact with them. Well, you'd be right—but only part of the time.

Certainly, in many cases, we feel most at ease with and most open to people we perceive as being like us. So if you're about to meet your in-laws-to-be and want to "fit in," some good advice would be to ask your fiancé how they normally dress or how their home is decorated.

Sometimes people feel most comfortable with others who dress in palettes that may not match their own but that nevertheless meet their expectations.

Because color choice tends to signify certain charac-
teristics, we can indicate that we possess those char-
acteristics by how we employ color.

For example, let's say you are going into a situation
where it would benefit you to impress people with the
fact that you are bold and future-oriented (perhaps
you hope to design brilliant new products for them, or
create a hot new ad campaign). Even if it's a group of
ultraconservative Color-Loyals you're addressing, you
will probably get more respect from them if your
choices of colors indicate that you are more adventur-
ous than they are.

On the other hand, if you are, say, trying to sell
annuities to a group of retirees—yes, even the ones
who sport outrageously colored golf clothes (a little
Color-Forward diversion geared for the sporting set
as a fun and energizing change of pace)—you want
to look conservative, thoughtful, and reliable. Your
choice of colors should reflect those values, and you
might want to leave any tangerine items hanging in
your closet right where they are.

RULES TO COLOR BY

In general, color personality rules are easy to observe,
and we have boiled them down to a simple trio. To

use these rules, it is necessary to think of the three color profiles in a sort of stack, with Color-Forward at the top, and Color-Loyal at the bottom.

Color-Forward
Color-Prudent
Color-Loyal

Now apply the following principles:

1. To convey to a person or group of people that you are on their wavelength, select your colors from the same profile palette as theirs.

2. To convey the message that you are creative, dynamic, and contemporary, select one profile higher.

3. To convey that you are careful, steady, and reliable, select one profile lower.

That's all there is to it—almost. You may be wondering if we're not forgetting something. That is, if you're stuck in one palette yourself, how can you make choices "outside your box"?

Well, here is the key. While nearly everyone else gravitates toward one color personality without being

consciously aware of why they do it (or even *that* they are doing it), you now have the gift of awareness. With awareness, change is not only possible, it's almost inevitable.

A good thing, too, because if you are going to be Color Smart, you are going to want to expand your personal options to fit given circumstances.

Energy and enhanced effectiveness are a direct result of flexibility, and of looking at old things in new ways. So to use these personality profile rules, you will have to turn a fresh eye on your color choices and ask yourself if they couldn't do with a bit more variety.

MOVING TOWARD THE NEXT STEP

We definitely don't recommend you run right out and buy this, that, and the other thing in fifteen different colors. For now, just start noticing different people's palettes and visualize yourself trying to communicate something to them through color.

Even after you do these mental exercises, don't go on a buying or painting or redecorating spree. In order to be fully Color Smart, you must first understand something in addition to color personalities. You must learn about the powerful signals that individual colors send.

TWO

Advanced Color Smarts
Understanding Color Signals

W e all believe that colors send signals, and
we are right.
No matter who we are or what colors we
may prefer, we all have one thing in common. Each
and every color we see creates a reaction within us.

We are so conditioned by color that we take these
reactions for granted. Our reaction is instinctive, from
the gut. We usually do not stop to think about it, and
we often don't even relate the color itself with what
we are feeling. But individual colors go hand in hand
with certain instinctive responses. Sometimes these
responses are physiological. Sometimes they are emo-
tional. And sometimes they are cultural.

Some of these color signals you already know.
Some may be entirely new. This chapter will discuss
these messages and then talk about how you can use
them to elicit the responses you want.

Over the years, the Cooper Marketing Group's research with 5,000 people has borne out just how pervasive color signals are. Instinctively, we associate colors with concepts. For example, if you were asked to think of a color that signifies "romantic," chances are you would think of red or pink. If you were asked to come up with a color that was "friendly" and "cheerful," you'd likely think of yellow (the classic "happy face" color).

Now let's see if you agree with some other associations from our research. Following are four concepts. For each, see what attributes come to mind and think about which colors best signal those attributes. You may want to refer to the color wheel and the color charts in the insert, showing pastel, dusty and dark colors.

Youthful

Professional/Businesslike

Durable

Mountain Air

Now let's see if your associations matched the majority of our respondents.

Youthful

These bright, energetic, red, yellow, and green hues are associated with being young. When children see them on a product or sign, they understand there's a message meant for them. Adults, too, think of these colors as youthful and use them when they want to appear young or as embodying the energy, vivacity, and enthusiasm of youth.

Professional/Businesslike

When we picture someone impressive, authoritative, capable, and serious, we visualize charcoal gray, black, or dark blue. This is the "uniform" for serious business.

Durable/Sturdy

The dark browns chosen here are not too dissimilar in their signals from the serious and reliable professional/businesslike colors. They indicate that an item has staying power. And black, which embodies strength, shows up in both concepts. No doubt that's why executives favor their leather chairs in these colors.

Mountain Air

Even something as ephemeral as mountain air has colors associated with it. We might not immediately have thought of this palette ourselves before we did our research but once consumers picked it, we immediately understood it. The soft, misty appearance of white, pale green, and blue certainly has all the positives we associate with being high up on a mountain. They appear refreshing and invigorating.

Why do we react to colors the way we do? The reasons fall into two categories. One has to do with physiology—the mind-body connection—and the other with culture, history, and learned responses.

THE MIND-BODY CONNECTION

Color creates within each of us a psychophysiological response. That is to say, it exerts influence on our bodies and our minds. This makes perfect sense in light of the fact that what we call color per se is, for the most part, inextricably intertwined with our own perceptions.

We see an object and its color as one—a red apple, an orange butterfly. But what we think of as red or orange is electromagnetic radiation vibrating at different frequencies.

Physically, colors are simply various wavelengths of that part of the electromagnetic spectrum that is reflected from objects and perceived as light. The color spectrum, i.e., all the colors of the rainbow, consists of hues of different wavelengths—with red having the longest wavelength and violet the shortest. The acronym for rainbow colors is ROY G. BIV; red and violet at each end of the spectrum, and orange, yellow, green, blue, and indigo in between. When we see an apple that appears to be red, it appears that way because the apple is actually absorbing all the waves of visible light except for the longest ones, which are reflected back to us. The rays hit receptor cells called "cones" in the retinas of our eyes. Voilá— the color "red" is registered.

But just what else do those wavelengths do?

In the colors at the ROY end of the spectrum, they excite and stimulate us. The long wavelengths of the hues from red through orange to yellow rev up the heart and nervous system. And when the physiological nervous system is revved up, our emotions follow suit. Thus, reds, oranges, and yellows can make us feel alert, active, and generally jazzed. Green is neutral in its effect. If it has more yellow it will behave more like yellow, and if it has more blue in it, it will behave more like blue. As we move through

blue to violet, the increasingly shorter wavelengths
have the opposite effect. They slow down our heart
rate and pulse, and are consequently peaceful and
calming.

THE CULTURAL CONNECTION

In addition to how color impacts us as physical and
emotional beings, it impacts us as well as members of
a society. Many of the associations we make with
color stem from things like what context we have seen
the color in before and how the color is used in our
cultural environment. We learn about color through
language, mythology, literature, and social practices.

The country in which we live and the culture in
which we were raised may have certain uses for par-
ticular colors, and we tend to absorb these as part of
our social learning. If you grow up in a society where
most brides wear white, for example, you will likely
come to connect the color white with purity, chastity,
and even new beginnings. If you come from a Latin
country where mourning is traditionally associated
with purple, you will likely associate purple, on some
level, with funerals. And you would not, for example,
expect to see purple as a popular everyday color. For
young women in Japan a kimono of soft pinks,

peaches, and cream is considered appropriate, but for older women it is not.

Cultural color associations can spread to other cultures, and in today's world, which is more and more connected, this is a rising trend. For example, the color saffron—the reddish gold shade of the robes worn by the Dalai Lama and other Buddhist monks— has taken on a meaning for many Westerners as both spiritual and exotic.

In addition, the associations made with a color can change within a culture over time. The biggest change we've seen in the United States is in the use of black. Black in the United States was once associated with the garb of European immigrant women and was considered unsophisticated. Later, when models and socialites adopted it, it was associated with daring urban chic. And later still, black became the uniform of those young people wishing to show they were outside the social establishment. Now that black has filtered its way to the average person, and even the average person's little kids, it has lost its shock value and become more middle of the road. Hence the ongoing hype about looking for the "new black" every season.

Another factor that scientists have begun to study recently is the effect of what has come to be called genetic imprinting. While we are each part of various

national, ethnic, and religious cultures, we are all members of a broader culture: the human race. Before written history, as far back as the dawn of humankind on the African savannas, we Homo Sapiens inhabited a gloriously colorful world. It stands to reason that we still react on a primal level to the color signals of the natural world.

Today, even those of us who are born and bred in an urban metropolis and rarely commune with nature in the raw react with positive feelings to the green of jungles and the blue of the sky. We are lulled by the color of a sandy beige; but we quickly learn to avoid the combination of yellow and black—which often signals danger in nature (as in bees, tigers, and assorted poison plants and fungi).

WHEN A ROSE IS MORE THAN A ROSE

So, all in all, while it may seem at first glance that a color is a color, the way a rose is a rose, there is actually a lot more to color signals. And once you understand the nuances of color signals you will be able not only to decode them, but to consciously craft them. You will be able to use color signals to communicate messages of your choice.

First, we will look at the signals of the colors in

the spectrum—red, orange, yellow, green, blue, and purple. Then we will look at the neutrals—white, gray, black, beige, and brown. Since we are Americans writing for Americans, we will focus for the moment on a contemporary American context.

Each color can send more than one message, and specific colors send more positive than negative signals. We will go over the most important messages—both positive and negative.

Then we will discuss using color signals alone and in combination with the three color profiles explained in the previous chapter.

ABOUT RED

Of all the colors in the color wheel, red causes the most active responses on a physiological level—heart rate, pulse, etc. Red doesn't just sit there, it draws attention to itself and commands the stage. It will not be ignored. In fact, in all cultures throughout the world, as language develops, red is the first color, after white and black, that is given a name.

And let's talk about the expression "warm color." Red, the most important warm color, somehow does make us feel literally warm. A room painted in a shade of red—even pink—can be set at a lower tem-

perature than a room that is painted a cool color like blue. For many years, red has been the preferred color for fine dining because of the warmth and good feelings it creates.

In nature, red is a color of opulence, of ripe berries and tomatoes, of rubies and garnets, of poppies and poinsettias. Let us not forget, it is also the color of blood and, consequently, the color of many religious sacraments, of hearts and of flames.

Red stirs strong emotions. The emotions themselves may vary depending on context, but whatever red brings to mind, one thing is for sure: The emotions it triggers will be strongly experienced.

Red is a color we associate with both love and anger. It is the color of sensuality, a favorite of young men choosing lingerie for their partners. It is also a color of festivity and celebration. The Egyptians started the tradition of red-letter days by marking significant writings and calculations in red ink.

Red signifies both danger and boldness in the face of danger, as in *The Red Badge of Courage*. It has decorated military uniforms throughout history and is, of course, the color of the planet named after the god of war: Mars.

It is a strong powerful color that comes at us boldly, never timidly.

Pink is related to red in that it is a pastel that results from mixing red with white. The difference in color signal when red is changed to pink is the same we see when any color is changed to its pastel version. So pink is often perceived as delicate, soft, pretty, and feminine. We mention it here to show how altering a color—through either changing its tint (by adding white), tone (by adding gray), or shade (by adding black)—can vary its meaning.

Pink, like red, can be a warm and exciting color. It is seen as romantic and sensual, so it is another favorite for lingerie, especially if it is a bright pink. Also, pink is often thought of as fun or frivolous— we're "in the pink" when feeling chipper.

But remember, what's delicate is often considered susceptible and ephemeral. In fact, in one of our surveys, 27 percent of 5,000 respondents said that "fragility" is best represented by the color pink.

ABOUT ORANGE

Orange, like red, is a warm color. It causes an increase in our heart rate and pulse. In the brighter shades, it really gets our attention—think hunters in blazing orange in a field or woods.

One of the key associations most frequently made

to orange is the word "spicy." And this tells us something about our attitudes toward orange. Similar to the way we appreciate spices in small amounts, we prefer to deal with vivid orange in limited quantities.

Give us a judicious bit of orange, and we think cheerful, invigorating, and sunny. Give us too much orange, and we think brash. Give us too much brashness, and for the most part, we think "cheap."

In contemporary America, though, there is an upside to this reasoning, and some retailers use it to their advantage. Consumers have come to associate orange with low cost and affordability, and using orange has been a way to signal bargain hunters to come on in. Home Depot discovered a proverbial pot of gold at this end of the rainbow.

Aside from using orange in small amounts, one can make orange more palatable by bringing out its quiet side through variations. Since changing a color to a pastel softens its effect, tinting orange with white turns it toward peach, a shade that signals freshness and health, and commercially relates to skin tones and cosmetics. Moving toward browner shades, such as terra-cotta, signals natural, mellow, and sunbaked. We think of far-off exotic places— Turkish rugs, chutney, and pottery from distant lands.

ABOUT YELLOW

Yellow alerts us and draws our attention, because, of all the primary colors, yellow is the most reflective and bright. It is the color we see first.

In practical terms, this makes yellow the easiest color to spot. People are sure to notice yellow warning signs and school buses. And then there's a personal favorite—yellow cell phones so we can see them in our purses.

Yellow and black in combination suggests danger. That is one reason why this combination is so effective in signs that warn us about school zones or twisty roads. But you might also find it useful to know that black type on yellow paper makes for the most easy-on-the-eyes reading. That is why the yellow pages are, well, the yellow pages. In psychological terms, when we see yellow, our brain thinks, "Aha, something new!" Yellow has the ability to signal something unanticipated and out of the ordinary.

We find a wide range of yellows in nature—everything from the sun, lemons, corn, saffron, glowing fires, and of course, gold, to golden wheat fields, natural maple wood, and cream and butter. It's no wonder that we think of yellow as hospitable, cozy, and comfortable.

Yellow is perceived as cheerful, upbeat, lively, and glowing. But yellow can also be relentless, and we can tire of it quickly if it is overdone. Did you ever meet a person who is so unceasingly sunny that, after your initial infatuation, you start to find them oppressive? Well, that's yellow.

Another downside to yellow is that it is sometimes linguistically linked in our culture with cowardice. Medieval artists portrayed Judas in yellow robes. Furthermore, we sometimes think of it as unscrupulous, as in yellow journalism.

In its bright, vibrant shades yellow is best used as an accent color (we will have more about accent colors later). But one can safely employ yellow in larger doses by adding a little white to get creamy, buttery pastels or soft, tinted whites, or by using a yellow beige.

ABOUT GREEN

Green can send a wide variety of signals. With more yellow it is exciting. With more blue it is calming. Green is the largest color family discernible to the human eye. Its wide range of shades and tones allows it to elicit diverse responses. In its darker and more neutral shades, such as hunter and forest green, green is linked with durability and reliability, and is used

to signal products that are environmentally correct.

Soft sages, mosses, celadon, and verdigris are perceived as restful. Jewel-tones such as emerald and malachite are seen as luxurious. Blue greens such as aqua, and green blues such as teal are thought of as bold when they are bright, but peaceful when they are tinted with white.

In nature, green comes from chlorophyll, a green pigment that is mostly tinged with varying degrees of yellow—consider the colors of grass, leaves, limes, mint, ivy, and ferns. We think of flower gardens and lush plants. And, for the most part, such green-yellow blends produce feelings of well-being, optimism, and springlike renewal. Not surprisingly, they even bring fertility to mind.

But add too much yellow to green—as in chartreuse—and it looks out of the ordinary. Negative responses begin. In this range, green can call up associations with envy (as in "green with"), illness and toxins (as in "so seasick that he turned green"), and mildew and slime.

ABOUT BLUE

Blue is the most popular color in this country. It is easy to like. It is comfortable, calming, and soothing.

It gives us a sense of well being. It calls up associations like constancy and contemplation. It is linked with loyalty (as in true blue), reliability (as in blue chips), and high honor (as in blue ribbon).

Blue is a cool color that seems to recede from us, rather than advance toward us as the warm reds and yellows do.

We find blues in nature. We have only to look at our gardens to see cornflowers, irises, forget-me-nots, delphiniums, and hyacinths, or in the wild to find lupines.

Of course, there are many shades and tones of blue. There are blues that are elegant, formal, and sophisticated, as well as blues that are casual and homey. Navy blue is considered businesslike, professional and dependable (as in a business suit). It can also be dependable in an informal way (as in denim jeans). Bright cobalt blue, which has a good deal of red in it, is viewed as rich, vibrant, and arousing. We find sky blues heavenly, and sea tones restorative and invigorating. The jewel tones—lapis lazuli and sapphire—are perceived as bold.

However, using blue is not as safe as it seems. Blue is passive—and so can sometimes be perceived as boring, even melancholy. We feel "blue" or sing the blues, and, for some, blue is a depressing color. But for most, used judiciously, it is a safe and easy color.

ABOUT PURPLE

Purple combines red's power with blue's elegance. Perhaps this explains why the color has long been associated with royalty.

In America, purple has moved from being a relatively unpopular color frequently associated with older women to a generally well-liked color.

With purple, it is easy to have too much. Perhaps this is because purple is a color that occurs less frequently in nature—only grapes, plums, eggplant, and a few flowers come to mind. And in large doses it strikes us as somehow artificial, overwhelming, or florid.

Recently purple has been used in children's products and characters. Remember the minor media furor that erupted over Jerry Falwell's public branding of Tinky Winky the Teletubbie—a popular children's character—as a gay icon, in part because of his purple color? The hubbub receded when it was pointed out that Barney the dinosaur, another kid's television favorite, was purple as well.

ABOUT NEUTRALS

In color theory, the traditional definition of neutral is a color that is neither warm nor cool. But in recent

years the word neutral has come to mean specific colors: black, gray, white, beige, and brown. We think of neutrals as sophisticated, because the use of these muted colors places emphasis on the overall design—picture modern architecture. These muted colors focus our attention on texture (berber carpeting) and content (black-and-white movies).

Neutrals can be used in large areas (beige carpeting) and can be used frequently (black clothing). They are successfully used by themselves or in conjunction with other neutrals. And they are wonderful when used as a background to intensify a strong color—the way black is used with red. Another example is Indian jewelry—silver (gray) with turquoise.

ABOUT WHITE

White, the absence of pigment, is associated with cleanliness, purity, newness, virginity, peace, and innocence. It can also mean quality.

As anyone who has ever walked into a paint store knows, there are endless nuances to white. If you put a bluish white (a cool white paint chip) beside a yellowish white (a warm white), your eye will instantly spot the difference. The first might bring to mind a frigid glacier, the second a luminous pearl. Never-

theless, no matter how hard it may be to decide on the right white, white usually conveys the appearance of simplicity. We view it as classic, timeless, and subtle.

However, white has a few negative associations—white lies, a white elephant, and the white flag of surrender. Use too much and you may convey sterility (as in hospital white). Use it without any other colors for accent or adornment and you may convey an impression of inexpensive and disposable (as in generic packaging or plain white paper cups and plates). Use a cool bluish white for an entire bathroom, and you may never get out of that warm shower for the entire month of January. And sometimes the ability of white to make something appear larger is less than desirable—except perhaps to convince us to start that diet. But as negative associations go, these are fairly mild.

ABOUT GRAY

Gray is a classic neutral. Gray surfaces reflect all colors evenly and no color dominates. It is a good background color, which connotes conservatism, traditionalism, and even intelligence, as in gray matter.

To tilt the balance of its neutrality in one direction or the other, gray can be warmed up by adding small

amounts of red and yellow, or cooled down by adding small amounts of green and blue.

In nature, we find the warm grays of granite and the cool grays of slate. With today's technology we can also choose grays with pink or lavender and a myriad of other complex grays.

Silver, a metallic gray, signals expensive. Charcoal gray signifies serious business.

Any negatives? A few. Gray can mean old. Gray all by itself is dull and uninteresting. But gray with other neutrals or other colors can be strong, bold, sophisticated, and beautiful.

ABOUT BLACK

Black is associated with elegance, sophistication, and sex. In apparel it is the foundation for urban women's wear. Often every woman in a business meeting will be wearing black. For formal occasions, a black tuxedo or cocktail dress is a sure winner. Black is another sexy lingerie favorite—perhaps because black also means danger.

Black is the color of night and death, of witchcraft (black magic), of illegality (black market and blackmail), of rejection (blacklist and blackball), and of outcasts (black sheep). In research with word associa-

tions, black is also associated with fear, anger, and depression. Black evokes an image of confrontation and the breaking of taboos.

In the upper echelons of the art, design, and fashion worlds, black was embraced long ago. Because of its association with taboos, it was considered a daringly different choice. In fact, black was so bad it turned good.

We all are familiar with the hordes of young people, all in black, who want to send a visible signal that they stand outside of established society. The irony is that pretty soon everyone else wanted to be taboo, too. Not only because black was trendy and somewhat naughty, but because it was practical, that is, easy to coordinate and easy to accessorize, and what could be better? It was slimming.

Today, you can find nearly any item in black—from the little cocktail dress to chinaware to toddler's T-shirts. Still, wherever one finds it, it hints of strength, power, and sophisticated, if somewhat safe, taste.

ABOUT BEIGE AND BROWN

Traditionally, brown has been seen as a strong and powerful color, but not as strong and powerful as black, red, or white. It is perceived as more casual than black or red, and is sometimes the perfect choice

to inspire confidence. For men especially, brown and beige are often the choices for relaxing—not just khaki pants, but brown leather recliners.

Beige and brown come from mixing other colors together. Brown and beige can be warmed by adding more red, as in terra-cotta, or cooled by adding green, as in khaki. Yet they evoke a fairly narrow range of responses.

Overwhelmingly, we think of brown as a natural color. We find browns and beiges in nature—woods, bamboo, sand, sisal, and autumn leaves. The list goes on and on. We can tell this even by the names we call its various shades and tones—mahogany, chocolate, coffee, camel, fawn, chestnut, mushroom.

We think of brown as the color of earth and forests, but also of home and hearth—for it is the color of bread and baskets. When we preface a food word with the word brown, we think wholesome and natural, as in brown rice.

Whatever its variation, brown retains its natural and reassuring character.

USING THE COLOR SIGNALS

As you have been reading along, it is likely you have already formed some of your own ideas as to how to make statements and send messages with color.

Throughout this book, we are going to suggest ways to apply color signals to a wide range of specific situations. For now, we offer the following overview of how to use some common color signals to elicit a desired reaction from people.

Use red when you want to grab attention and communicate something emphatically. Because red is such an active color, use it when you want to stimulate people, keep them excited, and heighten their motivation. Use red when you want people to perceive you as powerful. Red is also a good color to use when you want to speed up how people experience the passage of time. And don't forget red for passion.

But beware of using too much red. It can be exhausting and distracting.

Use pink when you want to connote warmth, delicacy, and femininity. Use it to suggest romance.

Beware of too much pink, or too light a pink unless you wish to convey softness or frailty. This may seem politically incorrect, but research shows this is simply the way we are programmed.

Use orange when you want to get attention or to convey creativity or a sense of being offbeat. Use it

when you want to show that something is exotic. And in certain contexts, use it to signal "low cost."

Beware of too much orange, especially a bright orange. It is harsh, jarring, and exhausting for you and everyone else.

Use yellow when you want to convey a sense of newness, excitement, fun, and surprise. Use yellow to draw attention to something. It says, "Hey, this is something—or someone—different." And employ it when you want to communicate a sense of sunny, good cheer.

Beware of too much yellow if you want to hold people's interest over time.

Use green in dark tones when you want to induce a restful feeling, when you want to suggest endurance and sturdiness, or when you want to relate to the out-of-doors.

Use it mixed with some yellow to suggest vitality and renewal, or when you want to communicate that something is refreshing. Use it with a lot of yellow when you want to show that you are daring or different and unafraid to show it.

Beware of adding too much yellow to green, however, or you will start to veer toward the icky. How

will you know if there is too much yellow in your green? Your stomach will tell you. If it makes you queasy, it will make others queasy too.

Use blue when you want to be relaxed and calm, or in situations when you want to play it safe and be a crowd pleaser, for we are a true-blue country. Blue is a conservative choice, connoting value and reliability. Use it when you want to communicate that you are loyal and dependable, especially in a business situation.

Mix blue with white for a hint of the heavenly. Use it in jewel tones or blend in some red to go bolder and more exciting.

Beware of overdoing solid blue in large areas, or some people may feel down. Also, with the exception of an odd berry here or there, we do not like blue food. Serve food in a blue light— as Alfred Hitchcock did at one notorious Hollywood dinner party—and watch people lose their appetites.

Use purple to connote grandeur, luxury, and expensive. Use it, too, to say you are a little out of the ordinary.

Beware of overdoing purple, as it—and consequently you—will come off as artificial.

• • •

Use black to suggest power and dominance, as well as elegance and sophistication. Use it, too, to signify stealth and strength.

Beware of using black to communicate how radical or out there you are. The days are long gone when black was true cutting edge.

Use gray to appear conservative, businesslike, and smart.

Beware of using too much without interesting accents, or you will come off as being neither here nor there.

Use white when you want to convey simplicity, purity, strength, and, of course, cleanliness. Use it when you want to stress efficiency.

Beware, though, that white may connote something cold, artificial, or plain, cheap, and throwaway.

Use brown to suggest naturalness and earthiness. Employ it also to communicate strength in a more understated manner than black or red. Use beige, too, for a natural, easy impression.

Beware of the brown or beige blahs, however. You will want to liven brown up with bright accents.

COMBINING COLOR SIGNALS WITH COLOR PALETTES

We suspect it is more than likely that you have already formulated in your own mind an important question: What if I choose a color to communicate a certain message, but the people I am communicating with do not favor that color?

Obviously, if you wish to use a color signal that is part of the palette of the people with whom you are interacting, things are straightforward. Let us say you want to use the color red for emphasis and excitement. Since red cuts across all color personalities—its signal is so basic that even the most Color-Loyal or Color-Forward person will respond to it—use it as you wish.

If, however, you want to use a color signal that is not part of your audience's preferred palette, you have one or two strategies open to you.

First, you can use any color as an accent color. If used in small amounts, and in combination with preferred colors, every color becomes palatable to a broad range of people.

Accents are commonly integrated into items of clothing such as scarves and neckties, and into home furnishing products such as tabletop accessories, throw pillows, and area rugs. Accents can also be

COLOR SMART

incorporated into a pattern. Also, think of accessories that you might carry with you, for example, briefcases, handbags, and even trim on business cards, brochures, and stationery.

With many colors, a little bit goes a long way. Accents may be just what is called for to make a point without poking people in the eye with it.

Second, you can soften a color by using its pastel version or render it less vivid by graying it down. These are all ways in which you may be able to communicate what you want with the color equivalent of a suggestive whisper.

What is more, you can move colors toward a color blend to offer a hint of a secondary message beneath a primary one—easy to do today because colors are becoming more complex. A reddish blue (cobalt), for instance, can contain the overt message of "reliable" and the latent message of "dynamic" all rolled into one.

BEING FULLY COLOR SMART

To recap the gist of these first two chapters, when faced with choosing colors to get a desired response, you'll need to take both color personalities and color signals into account. To elicit any desired response with color, just follow this simple sequence:

44

1. Decide what color palette—Color-Forward, Color-Prudent, or Color-Loyal—you will use as your base. (Remember, it might be the standard palette of the people you want to reach, or one up or one down.)

2. Select one or two key messages you want to send and choose signal colors accordingly.

3. Determine whether your signal colors are encompassed by your chosen palette, or if you need to "soften" your message by using signal colors as accents and/or in more subtle versions.

Color is already integrated into the fabric of our lives. Though you may not—yet—be consciously employing color knowledge in your dealings, you are responding to color palettes and signals all the time.

As consumers—at the supermarket, hardware store, clothing store, and auto dealership, just to name a few locales, we react in this manner each and every day. The following chapter will show how and why we respond to color in the marketplace, and explain how the use of Color Smart strategies by the people who sell us things assists and influences us in the choices we make.

Color Smart
Color Wheel in
Four-Color Process Colors

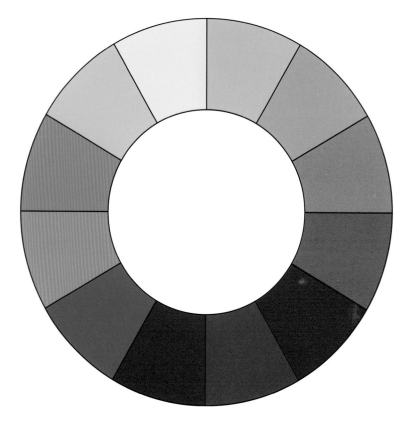

Color Wheel
Plus Variations

Color

Pastels
Color + White

Yellow

Yellow Orange

Orange

Red Orange

Red

Red Violet

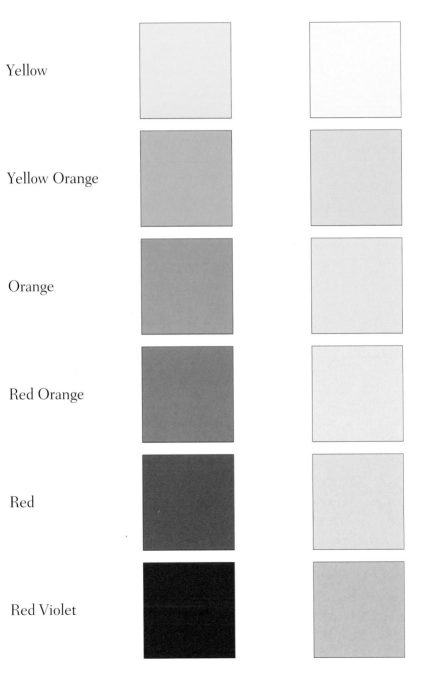

Color Wheel
Plus Variations

Dusty Color + Gray	Dark Color + Black

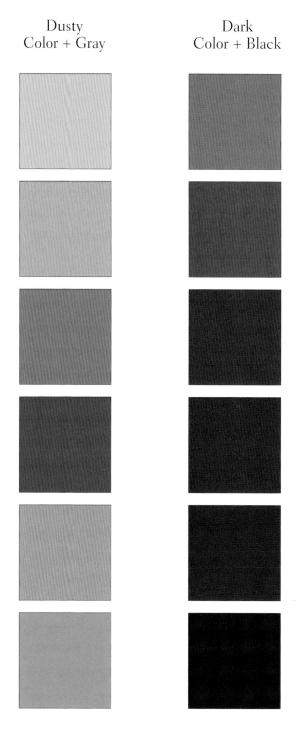

Color Wheel
Plus Variations

Color	Pastels Color + White

Violet

Blue Violet

Blue

Blue Green

Green

Yellow Green

Color Wheel
Plus Variations

Dusty
Color + Gray

Dark
Color + Black

Color Wheel
Plus Variations

Neutrals

Black

White

Warm Gray

Cool Gray

Yellow Beige

Orange Beige

Red Beige

Yellow Brown

Orange
Brown

Red Brown

Color Smart
Understanding Color Signals

Youthful

Professional/Business-like

Durable

Mountain Air

Forecast Colors

Grays

Violets

Teals

Golden Neutrals/Beiges/Browns

Greens

Reds

Color in the Marketplace

How the Pros Use Color

Every year, in corporate headquarters all across the country, and indeed the world, millions of dollars and thousands of man hours are spent conducting focus groups and doing vast amounts of research to consider critical questions of color. This is because companies in virtually all industries have learned to use color as one of the tools to establish a competitive edge in the marketplace.

As a consumer, all this attention to matters of color is to your advantage. (Believe us, it would be cheaper and easier, as far as businesses are concerned, to use less color, not more.) In ways we'll explain, all the attention devoted to color makes life easier, not to mention more interesting.

There are also some powerful benefits to you in

becoming aware of how color wields such a powerful influence in the marketplace. Understanding how the "big guys" use color will provide some very useful guidelines as to how you might use it in your own life.

In the many years that we've advised companies on all kinds of color issues, we've identified six specific strategies in which color is used in the marketplace to gain an edge. We're going to tell you about each one. Along the way, we're going to ask you to answer some "free association" questions—to show how automatic and ingrained some of your color-related choices tend to be.

BRAND IDENTIFICATION

Quick, what color comes to your mind first when we say:

- a can of Coke

- a bottle of 7Up

- a package of Kodak film

- a box of Tide detergent

- Avis Rent-A-Car

Did you answer red, green, yellow, orange, and red again? Congratulations! You are a typical color-conditioned consumer.

Now if you don't think that's a plus, just consider for a minute how much more difficult it would be to shop at the supermarket or navigate through the airport without such color cues. Every simple transaction would take you twice as long, and the chores of daily life would become more cumbersome and inefficient.

As it is, however, we are all so brand oriented that even if we were temporarily unable to read, it is a safe bet that we could negotiate our way through a supermarket, or a drugstore, or a department store cosmetics counter.

Brand identification using color is a natural outgrowth of the human mind's affinity for sorting and categorizing. We often recognize things by their color, processing the association so quickly we are not even consciously aware of what we're doing.

If we see a yellow bus, we don't have to mull it over. We instantly know what kind of bus it is. If we are out in the country and see a red building in a field, we think "barn." And if we see a pole with red and white stripes by a storefront, we think "barber."

If we were to do a bit of digging, we could likely

come up with some explanation of why such things are the colors they are. Why are barns red, for example? Because red is a natural color, but also because red paint used to be the cheapest color to buy. Why are school buses yellow? From our last chapter, you know yellow is the color the eye sees first and is the likely choice when you want to draw attention to something for safety reasons. How about barber poles? Since barbers also used to be surgeons, they were originally red and white because the red represented blood and the white represented bandages. Thankfully, barbering has come a long way. But a barbershop quartet will still clothe itself in barbershop "brand color" jackets of red and white.

It's fun to have a look at our world this way. As we walk down the street we see many things that are always the same color—like that red fire engine. Yes, you guessed it. It's the color of—what else?—fire. *And* it signals, "I'm going fast, so get outta my way."

But it may not always be entirely obvious why some man-made objects have come, typically, to be a certain color. Sometimes the reasons go so far back in history they elude us, such as the use of purple for royalty or people of high rank. And sometimes a certain color just "catches on" because of popular preference, and then itself becomes the tradition. Still,

once we associate a thing with a color, our psyche gets very hooked onto that habit. Often, in fact, those color codes inspire passionate attachment on our part.

People have always been inspired, aroused, and incited to action by such things as the colors of flags and coats of arms. If you want a current example, think about how the colors of a favorite sports team get a crowd to its feet. If you went to camp as a child, you no doubt remember when the camp was divided into rival teams for a tournament of competitive activities. What was it called? Color wars!

Imagine if this kind of fervor could be harnessed. Well, of course it is. When you look at it this way, it seems only natural enough that the good folks who sell us things want to use this phenomenon to their advantage. And they have been doing so, with great success, for quite some time.

In America, commercial brand identification goes back to the days when wagon makers each had their own particular combination of colors for the wagon bed, wheels, and running gear. If you lived in southeastern Wisconsin and saw a wagon of particular colors, you would be able to identify its crafter as Andrew Petersen of Whitewater. If you saw a different color wagon parked outside the blacksmith shop, you'd know it wasn't a Petersen. Different colors, different maker.

From wagons, it was a natural enough transition to employ color branding in mass-produced farm equipment. Cyrus McCormick, of International Harvester, chose red as the signature color for his tractors. He probably did so because of the association with red barns, but who knows for sure? Maybe Mrs. McCormick liked red roses. In any case, it wasn't long before anyone gazing out across the fields at a red piece of machinery could tell it was made by IH. The red machines became, in effect, their own billboard advertising.

Of course it wasn't a big leap for other farm equipment manufacturers to follow suit. Each wanted to block out and own a color. Indeed, in that industry, for many years the color orange virtually belonged to the Allis Chalmers company. John Deere used green, with an accent stripe of yellow. And each of these companies developed terrific brand loyalty. Farmers thought of themselves as "red" people or "orange" or "green" people.

It's important to note that once you move from one industry to another, the same color takes on a new meaning, a new brand association. Out in a cornfield, green may signify John Deere, but at the airport green is National Car rental. In the supermarket soft drink aisle, it's 7Up, but in the dishwashing section

it's Cascade. In the computing industry, IBM is "Big Blue." At the health food store, asking for the "blue tubes" will get you a Boiron homeopathic remedy. If you receive a piece of jewelry in a little blue box— hooray!—it's from Tiffany's.

When a new company starts up, or when an established company brings out a new product, color branding is one of their most important marketing decisions. They *need* a new color within their field to stake their claim. Still, you won't find a lot of radical choices being made when it comes to branding. Most contemporary brand colors are drawn from the Color-Prudent palette, so as to attract the greatest number of people and alienate the fewest. You'll rarely see a brand color be a new shade of chartreuse. In fact, if you were to do away with the most mainstream shades of red and blue, you'd do away with half the brand logos in America—Coke, Pepsi, IBM, Owens Corning, Mobil, 3M, Safeway, Philip Morris, Staples.

FEATURE REINFORCEMENT

All right, quickly again. If you were at the grocery and wanted to buy the *cheapest* product in any given category, which color packaging would you go for?

a) white with black

b) silver and gold

If you knew nothing about product names, but had to distinguish *detergent* from *fabric softener,* which package would you suppose contained the fabric softener?

a) pale blue

b) bright red

Did you pick choice A both times? Well, welcome to the world of feature reinforcement, where white with black means "generic and inexpensive" and silver and gold signifies "premium brand"; where bold red signals "strong" and pale blue equals "gentle."

In feature reinforcement, manufacturers use color signals to help consumers identify and distinguish between different kinds of products, different functions of products, different benefits of products, and different price points. Like branding, this strategy makes it easier for you to shop. It also makes it easier for people to signal potential buyers.

Feature reinforcement undoubtedly saves you valuable minutes every time you go hunting and gath-

ering in the supermarket aisles. Try a little once-around with this in mind and you'll see what we mean. Can you spot (without consulting the fine print) which vegetables have the cheese sauce? Which toothpaste has the mint? Which toothpaste has the bubble gum flavor for kids? Which furniture wax has the lemon scent? Of course you can.

Make no mistake, however: the scope of feature reinforcement does not end at the checkout counter. Walk out into the parking lot and look around at the vehicles there. Are there any black trucks? These are the "kings of the road," driven by those who fancy themselves he-men (and, nowadays, she-women). How about red sports cars? They're not hard to miss, because they say "Look at me!" (Like the fire engine does.) These cars are feature-reinforced with color to look like they're moving even when they're standing still. To whom do they appeal? Daredevils—or dare-devil wannabes. Look again and you may notice that the red Corvette is parked in the "no parking" zone.

Now take a drive to a store where appliances are sold. In the market for a vacuum cleaner? Originally people wanted a lightweight one for hauling around the house. That's a standard consumer preference. And vacuum manufacturers figured out long ago that consumers believed a product that was lighter in color

weighed less. So vacuum cleaners were white, beige, or pastel (and indeed felt lighter than they would in a darker color, because that's the way our brains work!). Now the important feature is "powerful." If we're looking for a shop vac to clean out the car and the garage, we want something that says "tough" even though it's tiny. Expect to find such an item in graphite gray or charcoal or red—and expect to perceive them as solid and sturdy for their size.

How about a trip around the sporting goods store? Notice how much workout clothing and shoes are feature reinforced with bright neon oranges and yellow greens. Why? Because such colors signify "energy"— and that's what we want when we're running, jumping, and pumping iron. As makers of sporting goods know, wearing a boldly colored new workout outfit may not pump up our muscles, but it will certainly pump up our psyches. Wearing certain shades and hues can actually provide more energy, and looking at those bright colors can stimulate quicker eye movements and better reflexes.

The companies we at the Cooper Marketing Group work with devote a great many resources to identifying the product features that are important to their customers. Then they do everything they can to alert their customers that these features exist. Often

they will do this by using color signals not only on products and packaging, but in advertising as well.

If you are interested in companies not just as a consumer but as an investor, it may interest you to know that feature reinforcement is also used on the covers of annual corporate reports. Look for companies who want to project their own image as serious, businesslike, and reliable to use black, blue, or charcoal colors to communicate these traits. White or yellow accents are signals that the company is doing new things. Color-Forward choices are rarely used in such a context. But we do know of one company that has used bright blue, yellow, green, and red to adorn its report cover. It was a little company in Redmond, Washington, that seemed to want to communicate it was really just a bunch of fun-loving folks having a good time, and certainly not a threat to competitors. Leave it to Microsoft to use color so cleverly.

When it comes to feature reinforcement, however it is employed, it needs to be right, or it can cause confusion and create more problems than it solves. Our research has shown, for example, that if at the supermarket you change the package of an inexpensive generic food product to more "upscale" colors, the buyer does not feel he is getting the same bargain.

Here's an incident that recently happened to a

friend of ours that illustrates how critically important it is for a product maker to align itself with customer expectations. This friend had a housekeeper who asked her to please never again purchase a new type of glass cleaner—that new cleaner being a shade of pink. Why not? Because, said the housekeeper, unlike the blue glass cleaner *of the same brand,* the new pink one left streaks. This, she theorized, was because it didn't have the same "anti-streaking" ingredient as its blue sibling. Our friend dutifully went back to the store and bought blue glass cleaner, but out of curiosity she did check the fine print on the labels. The two products appeared to be identical in their "anti-streak" property.

The moral of that story: When it comes to color, be sure to get your signals straight.

LINE DOMINANCE

Okay, today you're going to buy new carpeting for your living room. Two stores are directly across the street from each other and price their items identically. At the Carpet Place East you have a choice of half a dozen colors—and let's say they are the most popular carpet colors. At the Carpet Place West you can choose from among a hundred colors. Which one do you go to?

Come on, admit it. Whether you're Color-Forward, Color-Prudent, or even a diehard Color-Loyal type, you are curious about what's out there. You want to know you have freedom of choice, and you don't want to miss out. So much for Carpet Place East. Hello, Carpet Place West. And hello to a marketing strategy known as line dominance.

Line dominance simply means offering a product in so many variations that you become the dominant merchant of that product in your market. Either as a retailer or a manufacturer, you in effect become the "headquarters" at that price point.

Having a large color assortment lets the customer feel empowered to choose. Ironically, however, the majority of those choices will end up being in core colors from the Color-Prudent palette (because that's the category that fits most of the population).

The truth is that if retailers put carpet in stores the way people really buy it, the colors on display would be beige, beige, beige, beige, beige, maybe hunter green, one or two blues, one or two mauves and burgundies, a couple of grays—and beige, beige, beige, beige, beige. But who would really want to shop in a carpet store like that?! No one. If we saw that selection, we'd head off to another establishment, and be very happy they gave us so many more options. *Then* we'd buy beige.

The same phenomenon occurs when we go shopping for paint. We typically walk into a paint or hardware store and see signs for 1,200 COLORS or 2,000 or—best of all—MATCH ANY COLOR (the latter bringing to mind having satin shoes dyed to match the hue of bridesmaids' gowns). But any paint manufacturer or merchant will confirm that 70 to 80 percent of what they sell is in the white/off-white/soft beige colors.

Certainly there are retailers that cater more to a particular color group, for example The Limited and The Express for Color-Forward customers, L.L. Bean for Color-Prudent customers, and the Tog Shop—an old New England favorite—for Color-Loyal customers. But, in fact, to make significant sales a company must offer products to meet the wants and needs of all three groups. They have Color-Forward colors for their most Color-Forward customers, but also to project the image of the new and the fashionable to their Color-Prudent customers. These folks like to see what is new, think about it, and get used to it for the future. In this way they form the impression that the company is up-to-date. Today, even the discount chains—Target, Wal-Mart, and Kmart—are actively involved in projecting a Color-Forward image.

The feature of line dominance gives 100 percent

of its benefit to us, the customers. This is definitely one of those areas where consumers rule, and business serves. Henry Ford used to quip that his customers could buy a Model T in any color they wanted "so long as it's black." Then General Motors introduced colored cars and won a piece of the market. Soon enough, Henry and company had to compete— and American highways and byways became a good deal more colorful as a result.

THE TRADE UP

Have you ever paid more to get a product in a new or unusual color? Would you ever consider it?

Not everyone will answer yes to this question. But if you did, you are the kind of consumer for whom companies develop this next feature: the trade up. Color trade ups are most likely to lure "high-end" consumers, which translates into "people willing to spend more money." This is a share of the market everyone wants. But getting a piece of this market share can be tricky—and timing is often everything.

Most people reading this book probably don't remember when the phone company charged more for phones that came in colors other than black. Nowadays no one would dream of paying more for

this feature, because we take it for granted we can have phones in a myriad of colors. No big deal.

Most readers, however, probably do recall the hubbub that arose when Apple introduced its iMac computer in five bold new hues—blue, green, purple, orange, and red. Were people willing to pay more for the privilege of having a festively colored computer? Apparently. When a friend of ours looked into buying one shortly after they were announced, she was told by her dealer that if she wanted one in "blueberry"— apparently the most popular color—it would run her $50 more than "grape" or "lime" and $100 more than "tangerine" or "strawberry."

Customers have also been known to "trade up" in automobile colors. Many years ago, car buyers would pay top dollar to own two-tone Packards. More recently, they paid $5000 above sticker price to buy an iridescent Mustang whose shade seemed to shift from purple to teal as the light shifted. Household appliances and plumbing fixtures are some other areas where the "trade-up" effect of color is not uncommon.

Naturally enough, it's usually Color-Forward buyers who avail themselves of color trade-up options. Those of us who are Color-Forward pay more, and happily, because we perceive a new or atypical color as having greater value. We thoroughly enjoy the phe-

nomenon of being the "first on the block" to have a trendily colored item. Trade ups make manufacturers happy, too, in that in many instances adding a new color does not increase their manufacturing costs as much as it increases what they can charge for the item.

Of course, happiness can be a fleeting thing. Once the "new" colors of trade ups become commonplace (i.e., once everyone can get a phone in a color other than black or a refrigerator in a color other than white), competitors will offer a selection of colors at the same price, and no consumer will pay more. The trade-up feature will have to migrate to yet another new product area.

PIGGYBACKING

If you have just installed a new bathroom countertop in, say, malachite green, what else would you need in matching or complementary colors? Towels? How about a bathroom rug? A shower curtain? A toilet seat cover? A tissue box holder?

If you have just purchased a new brown pantsuit, what coordinating color items do you need to go with it? How about a blouse? A scarf? Shoes? A purse? Hosiery? Makeup with a brownish cast?

In product development, piggybacking is a kind of follow-the-leader game. Once a main product (e.g., a car) has been sold in a particular color, manufacturers who make supplementary products (e.g., car floor mats) must do or die—that is, they must gear their products to coordinate with the big ticket item in which the consumer is investing. That's why once those colored iMacs came out, it wasn't long before Epson and Kensington jumped on the bandwagon, tempting consumers with coordinating printers and trackballs. Apple, in this instance, is the "leader"; Epson and Kensington the "followers." But the winner in the game is the buyer.

Like line dominance, piggybacking is done solely to please and entice the customer. It's an expensive proposition to follow the leader. If, say, a leading range top manufacturer introduces a new color, then the range hood manufacturer needs to match it. Let's say he makes five sizes of range hoods, and three models. That means each time he adds a color to his line, he has to stock fifteen units.

But we, the consumer, will not be denied—no matter what our color palette preferences. If we are Color-Forward and buy our dominant products (e.g., the range top, the computer, the plumbing fixtures) in a trendy new color, we want our accessories to be dar-

ingly Color-Forward as well. If we are Color-Prudent, we may buy our dominant pieces in more mainstream colors, but enjoy taking a few more risks when it comes to using decorative accents in less expensive accessory pieces (bright coral napkins or tissue-box holders anyone?). But if we are Color-Loyal, we want to be certain that manufacturers keep stocking our tried-and-true colors, come heck or high water. If we were to go out shopping for royal blue towels and could only come up with teal, we would swear it was a Communist plot.

PRODUCT DIFFERENTIATION

Today you're in the drugstore and—sorry to do this to you—you have a cold. You don't feel like hanging around reading labels. How do you tell the cherry throat lozenges from the citrus ones? How do you tell the menthol decongestant elixir from the orange-flavored ones? Even in your sneezy, wheezy haze you know the cherry is red, the citrus is yellow, the menthol is green-ish, the orange is—well, orange. It's a no-brainer! Now, as you'll recall, this is feature reinforcement.

But now let's say you need to pick up some panty hose while you're at that drugstore. Sucking on your throat lozenge, you shuffle over to the L'eggs display.

You're still in no mood to spend a lot of energy reading labels. But can you spot the pair you need by its color code? If you're already used to buying this brand, you almost certainly can. And if you're not familiar with L'eggs coding system you will be the next time you come back. All it takes is a bit of color-conditioned memory. Manufacturers count on you to use it. That's why they use product differentiation within a line of goods.

Unlike feature reinforcement, where color signals evoke a traditional association from the customer, with product differentiation the manufacturer makes a discretionary choice and simply assigns colors to various products. For example, as milk has expanded to include whole milk, 2 percent, 1 percent, and fat free, dairies have arbitrarily assigned colors for labeling and caps. Likewise, when you go to buy your favorite brand of hot dogs, it's more than likely you instantly recognize that the package with the blue stripe is beef and the package with the red stripe is pork. There's no real reason for beef to be blue and pork red, other than that's what the hot-dog maker picked. But once you see it, you know it. And it sticks.

If you buy "lite" or diet versions of baked goods or salad dressings, can you pick them off the shelf at a glance because of color differentiation on the labels?

Of course. But woe unto the manufacturer who changes the relevant color codes—at least without one of those attention-grabbing NEW PACKAGE labels. No one wants to get home and realize they inadvertently bought the fattening stuff. They feel duped— not to mention a wee bit overstuffed—and that's not how you want your customer to feel.

USING WHAT YOU KNOW

As a buyer, you've long been on the receiving end of virtually all the strategies we've discussed in this chapter. But you may have taken them for granted, not really thinking about how they evolved or how they are used on you. We are certain that the next time you go shopping—be it for groceries, carpeting, appliances, cars, or what have you—you will now be more consciously aware of how color is used to influence you.

Better yet, you will probably begin to get some spontaneous ideas about how you can use color to influence others. And not only does color help you buy things, it can also help you sell them as well.

Applied Color Smarts
Using Color in Your Life

There's a certain amount of pleasure, even delight, in being aware of and understanding how color is used by marketing professionals. Once we know how colors are used to signal us to purchase products, we become more savvy consumers.

Even more interesting and delightful is to begin to consider how we can use color to enhance our own everyday lives.

USING THE SIX STRATEGIES IN DAILY LIFE

Throughout recorded history, for example, certain groups of people have used color as a kind of personal "brand identification." They have used their own colors for emblems, flags, and fancy clothing, which signified their lineage. As we've already men-

tioned, purple was often used exclusively by royalty. Oriental emperors were the only persons permitted to use purple, not only for clothing but for anything—flags, emblems, furniture, pictures, and even picture frames. And, of course, once upon a time the wealthy were the only ones who could afford to use gold.

In current times, we use color-brand identification to display our affiliations. At a University of Illinois home football game, the stands are lined with loyal alumni sporting bright orange and blue sweaters, pants, and even orange overalls. That's branding!

Have you ever gone to a family reunion, or sent your child on a school field trip, where everyone wears the same color T-shirts in a bright easy-to-see-at-a-distance color? You're using color branding even though you may not have thought of it that way.

Of course, there are numerous celebrities—today's "royalty," so to speak—who consciously use color as part of establishing universal recognition. There's "Nancy Reagan red" and "Johnny Cash black." And let's not forget Michael Jackson's white glove.

Feature reinforcement with color is also a part of daily life. Policemen dress in dark blue uniforms to reinforce their authority. Nurses wear white to pre-

sent a hygienic image. What feature do you think school crossing guard paraphernalia is meant to reinforce?

Now let's get back to celebrities for a moment. If you watch the news and talk shows, you may have noticed that people who are famous, or in some cases infamous, sometimes wear clothing that seems to have been deliberately selected to convey a particular personality feature they want viewers to believe they possess. We couldn't help but notice that when Linda Tripp, Monica Lewinsky's ex-best friend, appeared on Larry King to dissuade people from thinking of her as a betrayer of her girlfriend, she wore a shade of "true blue"—blue for loyalty and reliability. When Tonya Harding, once notorious for having a friend kneecap a rival skater, appeared on the *Today Show* years after the incident to resurrect her career and her image, she was swathed in an appealing pale pink—pink for softness, fragility, and femininity.

If you'd like to try enhancing your own image, or emphasizing some of your own traits with feature reinforcement, here are some general rules of thumb:

- For an energetic image, use brights, especially reds, oranges, and yellows.

- For a professional and businesslike appearance, use Color-Loyal dark blue, charcoal gray, and black. If those with whom you are interacting are a bit more daring, you might add hunter green or burgundy from the Color-Prudent palette.

- For an image of urban chic, obviously black is always acceptable, but so are neutrals like khaki, putty, and cream.

- For an image of being on the cutting edge, a trendsetter who is always trying the newest things, always choose Color-Forward colors. Decide how strongly you want to send this message. The more strongly you want to send it, the larger the area you should use Color-Forward colors on. To send this message subtly, use a Color-Forward hue as an accent only.

- If you're a woman out to attract a man, use black or scarlet red for a sexy image—that is, if the man you're trying to attract is young. If it's a more seasoned gentleman you're interested in, soften the signal by wearing cobalt blue or various shades of pink.

As always, knowing the rules of the game allows you to break them, so if you want to convey the message that you are not following the crowd, choose colors outside the norm. If you show up with purple hair or a neon tie, others will certainly get the point that you march to your own drummer.

Remember the feature called line dominance. It is the reason why retailers offer us such a wide selection of colors.

Most of us are already making the most of line dominance to enhance our lives. When we feel bored or a bit stale, we often turn to color to give us a lift and a sense of renewal. Our research shows that when we decide to update our homes, for example, color is the first thing we think of changing. Similarly, many of us—women in particular—describe a wardrobe as being outdated more because of colors than styles. Women who feel in a bit of a rut often use a change of hue to inspire a change of outlook. And because we as consumers demand this privilege, there is always another hue to turn to.

The feature we called "trade ups" also ties in with this notion. Often, when people wish to feel as if they've had a change in status, they will buy something in a new, more luxurious color.

Another way we tend to use color to give ourselves a psychological boost is through piggybacking—though this strategy, too, tends to be used by women more than men.

As far as most females are concerned, few things make us feel more that we "have it all together" than having a home and a wardrobe in which all colors go together harmoniously. When women change the main color of the exterior of our homes, we will likely also change the trim color, the roof color, and even the color of the flowers planted near the house. When a woman's clothes move toward yellow or brown or pink, she also changes makeup, hosiery, and accessories.

As for men, although they react to color just as strongly as women, they tend not to take an active role with it as much as women do. When a man goes shopping, he buys a new suit, maybe two. It's often a salesperson or his wife that reminds him that he needs ties, socks, and belts in appropriate shades to coordinate.

In our work and home, we also often employ the strategy of differentiation—or color coding. Remember how food product manufacturers, for example, use color codes to indicate which milk is skim or whole,

or which panty hose are small, medium, or large. Likewise, we may color code our kids' lunches so that little Jimmy, who only eats peanut butter, will not be sent off with little Jessica's tuna salad. And, while still on parenting duty, we may use it to avoid those awful sibling battles about, say, whose scissors are whose. (Jimmy's have the blue handle; Jessica's are purple.)

Once off the parent track and back at work, we use colored folders, boxes, labels, and dividers to keep our files, projects, archives, and appointments straight. I have discovered that I can actually keep track of all my expense receipts if I place them in a neon yellow number 10 envelope that stands out from amidst my perennial purse clutter.

Again, many of these color strategies are ones we employ almost as second nature. On some level we know that color is a tool for enhancing life, lifting moods, projecting messages about ourselves, and keeping things organized. But because color is such a natural part of our lives—such a "given"—most of us tend to use the tool without too much deliberation or planning.

Imagine if you did put a little premeditation into using color to get what you want. Imagine if you could

consciously use it to sell yourself, your ideas, your services, or anything else you might want to "market."

USING COLOR IN YOUR BUSINESS LIFE

One of the things we at the Cooper Marketing Group are most frequently asked is, "How can I use color to get ahead in the business world?"

First, let's look at what *not* to do.

A good friend of ours was interviewing for an important job managing a multi-location business. She bought a new suit in a beautiful shade, somewhere between kelly and emerald green. She knew she was well qualified, and she felt the interviews went well, but she didn't get the job.

A short time later she interviewed for another position. She had aced the initial interviews and all that remained was to interview with the people who would be reporting to her. She didn't get the job.

This time she had the opportunity to talk to some of the people who attended her final interview. They were candid. "It wasn't what you said," they explained, "but right away when we looked at you in that green suit, we thought you looked like someone we wouldn't get along with."

The next day she gave the suit to charity! She

replaced it, at our urging, with a navy blue dress with white trim. And the next similar job she interviewed for, she landed.

Where did our friend go wrong? After all, with her skin tone, hair color, and eyes she looked fabulous in the green suit. Nevertheless, it sent the wrong message.

For most job-interviewing situations, traditional colors used by Color-Loyals that signal "businesslike" are the most appropriate. That means navy blue, charcoal gray, and black. These tell prospective employers that you are serious and professional. See what you can learn about the organization's culture ahead of time (by looking over their annual reports, talking to people who already work there, and so on). If the organization is a bit on the informal side, you could safely move into the Color-Prudent palette a bit, wearing khaki, taupe or cream, hunter green (a subdued shade of green—very different from our friend's), and even incorporating accents of red or burgundy.

If, as our friend did, you are interviewing with the people who will work with you, wear clothes that are businesslike, but a shade or two softer. The white trim served to soften our friend's solid navy dress, but she might also have chosen an ensemble that was

medium or pale gray, or beige. The point was that she looked more *approachable*. More and more, as many companies move from an authoritarian management style to a more democratic structure that stresses teamwork, this is becoming an important signal to send.

Certainly there are exceptions to these general guidelines. If you are in marketing, advertising, sales, or design, Color-Forward colors signal that you are—as you should be—up on market trends. Still, don't overdo it. You want to indicate that you're a savvy observer of fashion, but not a slave to it. Use those Color-Forward hues as accents—on clothing accessories such as ties and scarves, or personal accessories such as pens and cell phones—to subtly but surely make your point.

With the explosion of color on so many products today, this is easier to do than ever. Indeed, just as we were writing this chapter Nokia introduced its line of cellular phones with multicolor snap-off covers for a quick change of mood. (The mascot of their ad campaign: a chameleon, of course.) Also, for a few dollars apiece you can treat yourself to an array of pens to fit your every message. We know someone who routinely attends power meetings armed with a three-dollar iridescent gold number, and usually says something

like, "I know I shouldn't show all my fancy stuff, but I just love the way this pen writes." Now there's a man with a message. His well-crafted accessory indicates humor, whimsy, unpretentiousness, and pragmatism all in one.

Now for another exception to the rules: Let's say you are interviewing for a job as a programmer in Silicon Valley, or as a physics professor at a university, where brains are the critical thing. Then you may want to appear not to be too concerned about your colors or clothes, as these are not exactly considered cerebral pursuits. Sure, you can wear colors, but while a ten-year-old Aloha shirt might be okay (signaling "I'm so busy thinking, I don't notice what I wear"), a Calvin Klein in the newest fashion color is not.

Now let's assume you've gotten your job, and you are in a position to have to present information to coworkers, or perhaps customers. When you are making a presentation as an authority—say, the financial plan for next year—then serious business attire is called for. Similarly, another friend of ours tells her employees, "Wear your black suit tomorrow if you want approval for that project."

If you are on a sales call or trying to convince someone to do business with you, these are also situations where you want to appear approachable, so once

again soften your colors a bit. If you want to signal that the product, service, or idea you're offering is new, groundbreaking, or unusual, you can signal that with accents. You may, for example, wish to put any innovative information you are going to hand out in Color-Forward folders.

Obviously there are countless numbers of specific business and workplace situations, and any number of individual messages you may wish to send using color. With the Color Smart principles you should be able to pair up colors with any situation. However, to give you some further ideas and inspiration, as well as to address some specific queries we are often asked, we offer this Q & A section as a sampling of useful things to know as you apply Color Smarts in your work life.

SOME QUESTIONS AND ANSWERS

Q: *I will be the only woman in a meeting among conservative businessmen. How do I appear strong and businesslike, yet feminine?*

A: To put a subtle emphasis on your femininity, stay away from solid navy blue or pinstripe. You will still be acceptable to Loyal or Prudent palette types in a deep scarlet or a cobalt

blue (the latter is not as dark as navy, and has
a bit of red in it, to signal power and energy).

Q: *I will be a woman in similar circumstances, yet
I think it's to my advantage not to appear too
powerful, or I'll put the men in my meeting
off. What do I do?*

A: Wear a conservatively colored navy suit, but
add a soft blue or pink blouse to appear less
formidable.

Q: *I am over forty, but will be presenting to a
meeting of much younger people. How do I
"look my age" but show I'm with it?*

A: Here is the perfect opportunity to use
accessories. You certainly don't want to wear
an entire Color-Forward ensemble. They
know what age you are—you can't hide that!
But a Color-Forward tie or shirt would be
fine. And consider a pen, folder, or phone in
a cutting-edge color, which you could pull
out to offer them a glimpse. We promise it
will pique their interest.

Q: *I am presenting a report to a bunch that is
certainly Color-Loyal. I know they won't*

accept anything else from me in terms of dress. But I feel best speaking in public when I'm dressed in bolder colors. What should I do?

A: Wear red boxers (if you're a guy) or hot pink undies (if you're not). We have a friend who swears by this method. He says his bright boxers embolden him and give him confidence. Without his "secret weapon," he swears he'd never give as forceful a talk.

Q: *I am trying to market an idea to a company with a very middle-of-the-road image. How do I not scare them away?*

A: Dress from the Color-Prudent palette, so that they perceive you as someone who is like them and who understands them. But on your slides or folders use a bright sunny yellow trim, which indicates "this is something new."

Q: *You say bright colors like red and orange make people alert and excited. Why don't I just use a whole lot of these in my presentation to get everyone revved up and eager to do business with me right away?*

A: Because there can be too much of a good thing. Remember that there are psychophysiological responses to such colors. Heart rate, pulse, and eye movement increase, and the whole body becomes energized and ready—but not necessarily ready, say, to sign a contract. In business meetings you also want to earn people's trust and not set them on edge. Too much color stimulation works at cross-purposes with these goals. So when you excite people with color you want to do it with judicious amounts, or with things they will only see for a short period of time.

What's more, after looking at a bright color for a long period of time, the reverse effect may set in. You don't want to leave the meeting with people yawning and fuzzy-brained, unable to make a decision.

Q: *What colors should I use to decorate a room that will be used for daylong meetings?*

A: Use shades that are pleasant and easy on the eye. These will help people concentrate and relax. Then add bright accents here and there for energy. For the accents, consider yellow-

based reds such as corals, and also terra-
cotta, aqua, or turquoise. Stay away from too
much blue. Though blue calms and relaxes,
too much can cause boredom or depression.

Q: *I am interviewing for my first job. The place
where I want to work has a casual atmosphere,
but shouldn't I dress very elegantly and be
conservative with color to show my prospective
employers I "mean business"?*

A: Actually, no. Stick with khakis and a light
blue shirt. Don't try to "out-dress" prospective
employers, but don't under-dress or look too
wild either. The color combination of light
blue and khaki signals youthfulness and
seriousness simultaneously (not to mention
neatness, which does count). You will look
like someone who will come in and give a lot
to the job.

Q: *I know red is a universal power signal and all
that, but the truth is I hate wearing or using
anything red. I think I look awful in it. Must I?*

A: Of course not. Thankfully, there are no Color
Police. If you are not comfortable wearing
something, no one you are interacting with

will be comfortable either. What we are offering are guidelines. If you don't like red, use one of the many other colors that can send similar signals, such as cobalt blue.

COLOR SMARTS FOR SELLING YOUR HOUSE

Another question we are frequently asked is how people can use color to help sell their homes. Indeed, every realtor we know agrees that color affects how a prospective buyer thinks about real estate.

In general, buyers like houses that are in soft neutral colors. On the practical side, they can move in without having to make immediate changes. On the psychological side, they feel comfortable with these hues. Soft neutrals signal would-be buyers that the current homeowner plays by the rules. Conversely, an exceptionally bright or unusual color makes buyers wonder about the seller and the house. Are there other hidden things, they fear, that are out of the ordinary?

In addition, we have categorized five different ways in which particular uses of colors can help move your house quickly.

- *Use color to make your home seem more up-to-date.* Though your large surfaces (painted walls,

wallpaper, carpets, etc.) should be soft neutrals,
using Color-Forward decorative accents
throughout sends a positive message to buyers.
Even though they won't be purchasing your
decorative items, they still convey the
impression the house is more modern and well
maintained. If you have not incorporated the
Color-Forward palette in your decor, you can do
so quickly and inexpensively with such items as
flowers, towels, candles, and placemats.

- *Use color to make your house seem more
 luxurious.* We have a friend who decided to
 purchase one house over another she was
 considering because she fell in love with its
 front door, which was painted in a shade of deep
 purple. She said it made her feel like a queen.
 Later, we heard many other homebuyers
 mention similar things. Colors made the
 difference in whether they perceived a house as
 upscale. Consider adding luxurious shades—
 purple, scarlet red, jewel tones—to features of
 your home that say "welcome."

- *Use color to make your house look larger.* A
 realtor told us of a house she was having trouble
 selling. It was painted a soft putty color—and

only that color—all over. She said people perceived it as small, though in fact it was quite roomy inside. At her suggestion, the owner repainted the house's shutters and trim in hunter green and white. He also added a red awning. The colors had the effect of adding dimension to the house and making it look larger. Then it did sell quickly.

- *Use color to make the house look lighter and brighter.* If you have a room that does not get much light, perhaps because it is north facing or has small windows, be careful about using too much blue in it. The dearth of light, combined with a color that is "cool," may make the room seem lifeless. To bring the sunshine in, use coral or lemon yellow accents. Flowers are one way to add such accents without much cost or fuss.

- *Use color to orchestrate traffic flow.* If there's a room you want sellers to move through quickly (without noticing its little flaws, perhaps?), see if you can sneak in some bright orange or teal items—because it's physically exhausting for the eye to look at these colors for long. Where you want buyers to linger, use burgundy or green.

COLOR SMARTS FOR SELLING YOUR CAR

Now that you've sold your house, would you care to sell your car, too? Obviously it helps if you've kept it in good shape—and no rolling back that odometer!—but it also helps resale value if you have a car in an "appropriate color."

We all know that color is an important part of a car's image. In this country, most of us want to buy a new car in a different color than our old one. (The 10 to 15 percent of us that do buy our new car in the same color as the one we are replacing tend to buy black or white.) A new color car not only enhances our pleasure, but it guarantees that our friends and neighbors will be able to tell instantly that we have a new automobile.

However, think carefully before you select from that color chart. A good way to up the odds that you will be able to sell your old car for a good price the next time you want to buy a new one is to make certain you buy cars in colors that fit the cost and classification of the vehicle. That's what we mean by "appropriate."

Expensive cars should be in colors that "look like money." They should signal luxury by being silver, champagne beige (with a hint of gold), black, hunter green, navy blue, burgundy, or white. Notice these

colors are all traditional colors that appeal to Color-Loyals. If you want a Mercedes in yellow, get it. But be aware it's worth less money to prospective buyers than one in a "luxury" shade.

Mid-priced cars, including sedans or sport utility vehicles, should look serious and durable. They can either be in luxury colors or in more Color Forward colors, such as khaki.

Less expensive cars can be in the colors of mid-priced cars but they can also be in bright, fun colors. We delight in the peppy hues of Volkswagon Beetles and accept, on those "bugs," colors we might abhor on other autos. The colors are part of the car's appeal to its target market—those who want to stand out in a crowd.

Trucks and "muscle cars," such as Corvettes, are best in strong colors. The classic sports car is red. And the classic truck may be black. But Color-Forward men often prefer trucks in blue, because they say they love the way the color of mud looks on the side of a blue truck. (Hey, we just do the research. We're not making this up!)

THIS AND THAT

As you have doubtless begun to see, the Color Smart formula can be applied to just about any item or situa-

tion. Just figure out what impression you want to convey and select colors that convey it. But be sure to consider any specific circumstances that apply to your situation.

We've had people ask us, for example, how best to use Color Smarts to stage a yard sale. The answer is it depends what kind of merchandise you want to move. For a big sale with good bargains, why not use neon orange for your signage? It says "Lots of cool, cheap stuff here!" For an estate-type sale that includes fine items, consider a sign in silver and gold. Context is everything, so let it be your guide.

Interestingly enough, many people ask us about what colors they should use if they are staging an activity that involves their kids—for example, building a lemonade stand or having a birthday party. In this instance, we need to alter our perspective a bit. Kids relate to color differently than adults do.

Kids' Colors

Color is a salient feature of childhood. Kids enjoy color, respond to it, are intrigued and invigorated by it. Yet in many ways they react to it differently than do adults. If you're going to interact with children, as a parent, grandparent, or educator of any kind, color can be your ally. But you'll need to adjust your Color Smarts accordingly. Children start with a limited palette and expand into more and more colors as they mature.

FROM MOBILES TO BARNEY® AND BARBIE®

Color is one of the first things infants see and differentiate. We've all heard that infants see in black and white (dark and light), and new parents often salt-and-pepper their newborn's rooms with black-and-

white mobiles, posters, stuffed critters, and the like. But at six weeks to two months, such paraphernalia becomes a bit obsolete. First, infants begin to notice the color red (which undoubtedly ties into why, as language develops, red is the first color to get a name). Then they move on to noticing other bright colors, such as yellows.

Young children's attraction to brightness is universal. Numerous academic studies, however, as well as our own empirical research, indicate some distinctions as children advance in years. Up to about age ten, most children will name red (pink, too) or yellow as their favorite color, but after age ten there is an increase in the number of children who start to prefer blue. We believe this has to do with maturation and the ability to accept a greater complexity of moods.

Some children's color preferences are definitely gender related. No matter how many studies are conducted, it turns out that overwhelmingly most little girls like pink, lavender, and purple. Young boys are drawn to black and other dark colors before girls. Many times we are asked if such preferences are inborn or culturally conditioned. The latter point of view presumes adults actually unconsciously train girls and boys to like certain colors by the clothes we

dress them in and the items we surround them with. No one can say for certain, but if we had to bet we would put our money on inborn, genetic imprinting. Whatever its cause, it is a phenomenon that seems set in psychic stone.

Do toy manufacturers know this? Take a walk down the Barbie aisle of your local toy emporium, and then check out the action figures aisle. Notice the difference? It turns out they know it very well indeed.

Children automatically gravitate to products that are in the hues they prefer. Those who market products to children know all about the importance of children's color preferences and use color to grab children's attention and to sell to them (or, rather, to sell to parents who can't resist their little one's charming pleas).

Like companies that sell to adults, companies that market to kids also use such strategies as branding and feature reinforcement with color. Barney is purple— it's part of his persona. Now many small children who had no particular preference for purple have come to have a positive association to it as "Barney's color." Before Ariel®, the Little Mermaid, red hair was rarely used on dolls, and neither were green dresses. Now, if your little girl wants to be Ariel for Halloween, both the red hair and the green dress are "musts." Boys who

want to be Superman® use his familiar blue, yellow, and red.

As for feature reinforcement, gender identification is certainly just one common example. It's also one you can test for yourself. Just try getting little boys to believe the pink party favors are for them. In addition, in any cereal aisle you will notice manufacturers using bright colors on boxes of certain cereals to signal to kids, "Hey, this stuff's for you."

Some parents tend to get a bit cynical about how kids are tempted by crafty consumer marketers at such a tender age. But consider how reinforcement with color has also tempted kids to do constructive things, like get interested in books. Dr. Seuss was a master of reinforcing with color signals. His strangely colored animals tell children that when they enter his world they are going to find many surprises and have a great deal of genuinely silly fun. Think of *Green Eggs and Ham*.

With children, as well as grown-ups, color is a tool. And tools can be used by anyone, in many different ways, to create all sorts of results. There's no need for business to be the only ones to reap all the benefits of kids' fascination with color. We can all employ color to engage, instruct, and inspire the youngest generation.

APPLIED COLOR SMARTS WITH KIDS

First, let's take a look at how children learn about color itself. Children learn to recognize and differentiate colors before they can name them. They will, for example, point toward or stare at colorful objects before they can proudly say "red," "yellow," or "green." Color naming itself generally begins anytime from age two to five. Girls generally master color naming before boys. Of course, individuals may vary in their development as this skill has to do with the maturation of specific cortical neurological structures.

If you want to help your children learn to master color naming, several studies have shown that kids learn both color naming *and* object naming more quickly when objects are paired with appropriate colors. For example, here are some common associations the average kid might relate to:

Yellow—bananas; lemons; the sun

Red—apples; tomatoes

Blue—blue jeans; the sky

Green—beans and peas; grass and leaves

Gray—elephants; pigeons

Brown—bears; tree trunks

Research shows that if you show a kid a picture of a blue apple, as opposed to a red one, and ask them what the object in the picture is, it will take them longer to recognize it as an apple. Of course, if you're familiar with little kids, you probably already know what else might happen. They are likely to think that a blue apple is funny. This is evidence of development of that most wonderful attribute, a sense of humor, which observes and delights in incongruities.

There are, by the way, many wonderful books that can assist you in teaching kids about color. A few we especially like are:

My Colors: Let's Learn About Colors by Jonathan Lambert (ages 2 to 4). This is a tall, sturdy book with thick white card pages and ten colored tabs. Each tab opens up to a double-page spread of objects in a single color. The green tab shows a frog, a peapod, and a leaf. The colors include gray and pink, as well as more common hues. Nearly all the objects can be easily recognized by most toddlers.

Brown Bear, Brown Bear, What Do You See? By Bill Martin Jr. and Eric Carle (infants to preschoolers). The gentle rhyming, good humor, and colorful, bold illustrations make this one of the most popular children's books on color. On each page we meet a new animal who nudges the child onward to discover which creature will show up next: "Blue horse, blue horse, what do you see? I see a green frog looking at me." This pattern is repeated over and over until the child can chime in with the reader.

Jigsaw Puzzles: Color Puzzles by Deni Brown (infants to preschoolers). It's a book and a puzzle. Loads of color-filled fun.

Chuck Murphy's Color Surprises: A Pop-Up Book by Chuck Murphy (ages 4 to 8). Each page of this artistically done pop-up book features a single, solid-colored square. With a quick pull, one of nature's creatures slithers, flies, or bounces out of the square. Great for kids who love animals.

There are, in addition, many toys that help children learn their colors. The Fisher-Price Rock-A-Stack, which organizes brightly colored plastic rings

according to the spectrum, is a classic. Another favorite is Attribute blocks, a standard in nursery schools, that consists of blocks in five colors in five shapes, each of those shapes in five sizes.

As nice as these learning aids are, of course, they are not mandatory. One really doesn't require anything at all except a willingness to look at the world around us in order to help children learn about color. We can use virtually any simple single-colored object to enable a child to practice color naming. What color is the child's favorite juice? Favorite blanket? What color is milk, grass, Mama's lipstick? What is the color of *this* autumn leaf? How about *that* autumn leaf?

Now here is some really good news. Once a child has learned to differentiate and name colors, using color can help the child absorb other information more easily. Sarah, my five-year-old neighbor, first learned to recognize the state of Illinois on her United States map place mat because Illinois is purple. She then learned to identify all the other states where her relatives live, also by color. But then she quickly moved to remembering the states' locations, and can find them on any United States map. (Imagine how surprised Sarah was during her first plane flight to

look down and discover each state was not delineated with a separate shade.)

With very young children, parents often wish to concentrate on teaching issues of safety. We have found that color reinforcement is a wonderful way of helping children to learn what is dangerous. Remember, the human eye sees the combination of yellow and black easily, and the human brain is genetically imprinted to associate it with danger. So consider using such colors to mark items you do not want your children playing with or near. You might also want to consider strips of neon tape to demarcate areas where children ought not venture or need to exercise caution. A neon yellow strip on the edge of the bottom stair to our basement probably would have saved our daughter's front tooth when she was two and a half.

Even when kids become adolescents, color can still be a highly effective learning aid. A study by Dr. Sydney Zentall and associates at Purdue University in Indiana showed that adolescents with attention problems performed better at tasks when color was used to add visual stimulation to those tasks. In general, performance was as improved as when stimulant drugs were used. This is very promising indeed in terms of how color may one day be used as a medical treatment.

EXPRESS YOURSELF

Another very important skill children can be taught via the use of color is that of free expression. Children love to know the rules, but they also love to be silly. Children who are allowed to pick out colors for an art project, or select a colored item that will decorate their room, or pick out what clothes they want to wear by color, gain self-confidence and have the experience of being "themselves." But be forewarned, sometimes the colors they pick wouldn't necessarily be *your* first choice. My granddaughter, Anna, at age four, purposely chose and wore mismatched socks on a daily basis. The fact that this was allowed, even praised, made her feel wonderful about expressing herself. (Incidentally, it saved her parents all that time typically spent hunting for sock mates that mysteriously disappear in the laundry. So it was a win/win situation.)

Color is also a very useful tool in helping children to express their emotions—perhaps even, or especially, emotions they have trouble expressing in words. Many studies have confirmed the interrelationship between color and mood. For example, it's been observed that children are more likely to color with a yellow crayon after hearing a happy story, and with a

brown crayon after hearing a sad story. *The Journal of Genetic Psychology* reported a study that displayed distinct color-emotion associations for virtually every child that participated. One finding showed that, in general, the light colors corresponded with positive emotions and dark colors with negative emotions.

Is your child feeling happy, excited, sad, scared, or angry? One way psychotherapists help them differentiate between feelings and learn to name them and talk about them in a constructive way is to open a dialogue using color. They use a technique called Color-Your-Life, which was developed by psychologist Kevin J. O'Connor. It works best with children over six who have mastered the ability to name colors *and* their own feelings.

With this technique, the therapist uses a white sheet of paper and a variety of perhaps eight or nine crayons in basic colors such as yellow, red, blue, green, purple, gray, black, etc. The child is asked to pair feelings with a color (often yielding results like red/angry, orange/excited, or gray/lonely). Then the child is given a blank page and asked to draw the feelings in his life (for example, if they're happy sometimes and sad other times, they could use some of each color they associate with those moods). It is fascinating to see what colors the child selects, how

much of each is used, and in what order the colors are chosen.

STRONG OPINIONS

Whatever color-related activity you may choose to do with a child, it's likely to go best if you let them participate in selecting the colors involved. If you force a color, or anything else, on a child you may have quite a rebellion on your hands. And if you make a color faux pas, you're likely to get quite an earful. (By the way, if you want to play it safe with boy/girl parties and not alienate either gender, we suggest proven "gender-neutral" child-friendly shades such as red, dark purple, and teal.)

As far as we're concerned, however, this is a wonderful, safe area in which children can begin asserting themselves. But be forewarned, children often have strong opinions not only about the colors they prefer, but the colors they think *you* should prefer. My mismatched-sock-loving granddaughter once opined that her mother's sexy black party dress was definitely not something worthy of Barbie (whom she said would have preferred "anything pink"). Fortunately, her mother, who knew to take this with a grain of salt, enjoyed her party nonetheless.

As children grow older, their color preferences can become even more important to them. The preferences themselves, however, are apt to change as they come under different, expanded influences. Between five and ten years old, once school friends and associations take on increasing importance, kids broaden their color interests. Some—usually girls—pride themselves on how many colors they might have in their wardrobe or use in an art project . Some children covet the Crayola boxes with forty-eight, sixty-four, or, best of all, ninety-six colors. Others—often boys—expand their color preferences to include colors used in favorite sports (such as the neon "hot rod" colors of auto racing) or favorite sports teams (the Chicago Bulls' colors of red and black became best-sellers in this age group during the Michael Jordan era). Children, often the boys, also go in for colored food items that are considered "gross" or "yucky" by the opposite sex or adults, and you'll sometimes find them gleefully downing delicacies like blue gummy worms.

Both boys and girls become increasingly influenced by electronic media during this period. The hues of the licensed characters of the moment, like Pokémon, take on ever-increasing appeal. In addition both genders are attracted by the special-effects pig-

ments that improved technology has made possible. These new finishes, which involve sophisticated refraction of light and include metallics, pearlescents, and iridescents (surfaces that look one color from one angle and another color from a different angle) are found in everything from baseball cards to jewelry to books.

Once the teen years hit, and those cute little boys and girls cross the puberty line, their desire for the new and previously untried expands into all areas— and color is no exception. The words "practical," "classic," or "ever-popular" are anathema to teens. What they want most of all is anything that has not been previously accepted by their parents. Blue nail polish? Sure. Brown lipstick? Absolutely.

Teens are Color-Forward with a vengeance. And their passion for the new and adventurous moves the market. For companies who market to teenagers, especially to teenage girls, line dominance is critical, and offering a vast array of shades, including the newest and most outrageous, is essential.

Of course while marketers may love teens' penchant for the most up-to-the-moment, it can drive parents around the bend. Those of us who have raised teenage daughters may remember hearing, as we got dressed to leave the house feeling pretty good about

the way we looked, "You're not going to wear that old eye shadow, are you?" and "Do you have to wear that length skirt—and in *that color?*" And while most teenage sons don't tell their parents what to wear, they are very opinionated indeed about what color car they ought to buy. It seems they only want to borrow the trendiest vehicles.

Unless you reside in never-never land, of course, your children and teens grow up. And most of them will temper their extreme Color-Forward enthusiasm with a dose more pragmatism. Eventually, they may even regret their past excesses.

I still have a beach towel my daughter Nancy picked out by herself as a kid. It is *very* bright orange, purple, and green. She used to adore it, because we let her choose it, and that was, to her, a sign she was being treated more like an adult. Now when she sees this relic she complains, "Mom, did you have to buy that in such lasting quality?"

SIX

Place Palettes

The Colors of Foreign Countries

My daughter-in-law, Noriko, has studied flower arranging, and one day we were talking about different cultural approaches. She mentioned that in England, the flowers tend to be soft and pale, the hues of an English garden. In France the colors chosen are bolder, as if borrowed straight from the canvas of an oil painting. So began my quest to understand the similarities and differences in the use of color and color preferences in other cultures and countries.

Just as one must employ Color Smarts somewhat differently when dealing with children rather than adults, one must adjust one's Color Smarts accordingly when dealing with foreign cultures. Though color signals based on emotion and genetic implant-

ing are ubiquitous in nature, each region of the world has its own predominant colors.

Though our emotional reactions to colors are to some extent "hard wired," they are also the result of cultural conditioning, with each region having its own distinctive palette. This palette is to some extent determined by the climate and light of the country (for example, in desert climates people use colors with high reflectivity to keep cool), but is also influenced by its cuisine, its important cultural rituals, the temperament of its people, and even the physical characteristics of its residents.

Anyone who wishes to connect with citizens of another country, either on a personal or business level, will find that connection made easier by building a bridge with color. In such a circumstance, think of utilizing a customized Place Palette, i.e. a range of colors with which the majority of people in the land to which you are traveling feel comfortable and familiar.

SOME GENERALITIES

When we travel to foreign countries, we often worry about violating taboos or committing a faux pas when it comes to color usage. If we are doing business we surely don't want to get off on the wrong foot and we

certainly don't want to offend anyone. Let me pass along to you a tip I learned from a well-traveled friend: Always ask before you go if there are any colors that should *not* be used.

When it comes to color, the primary taboo generally has to do with wearing the colors of mourning in inappropriate circumstances. In more traditional and insulated countries, one might find that certain significant colors are reserved for use on special occasions or for certain groups. So, it pays to know before you go.

In general, we have learned that the countries or cultures that are more insulated politically, socially, and economically also have the most traditional and rigid attitude toward the use of color. As cultures open themselves up to new ideas they also expand their color palette. They are more open to using new colors, as well as to using them in heretofore untried ways.

In this chapter, we'll take you on a colorful world tour. Though time and space, of course, preclude stopping everywhere along the way, we'll visit some fascinating locales. And from what you learn we are sure you will develop the knack of discerning the appropriate Place Palette for anywhere your own journey may take you.

AFRICA

When we think of colors associated with the African continent, we usually think of strong, bold, and saturated colors—reds, yellows, oranges, greens, and black. We think of natural pigments, of lushness and fecundity. But there is more to the colors of Africa if we look a little deeper. Here are a few examples.

The Tuareq people are nomadic travelers from Timbuktu who traveled in the Sahara. Their trade once brought them riches, but because of changing economic conditions they are no longer affluent. They are an insular people. They don't marry people outside their group—and in fact have very little to do with outsiders at all. They wear a traditional three piece outfit, called a boubou, and the *only* color they wear is indigo blue. In fact, because the blue dye on their clothes often rubs off on their skin, they are sometimes referred to as the "blue people."

On the other hand, the Bambara tribe in Mali are a people who have been more flexible. Traditionally farmers, they now primarily fish and herd. Their culture is changing, and they are moving toward a less insular way of life than they previously knew. They maintain contacts outside their tribe and even inter-

marry. And what about color? You guessed it! Though clothing is still traditional, they wear many colors.

The Bambara have incorporated into their way of life some of the social uses of color that we find throughout much of the world. For one thing, they use certain colors as a sign of wealth. The tribespeople buy fabric that is then made into clothing. Since solid-colored fabric is more expensive than print fabric, solid colors are seen as a status symbol. And among the solids, the deep saturated colors that take longer to dye—such as dark purple, gold, or hunter green—cost most of all. Hence they signify the greatest wealth.

For another thing, the young tribespeople wear bright colors—hot pink, canary yellow, bright orange, and bright green—while the elders tend to gravitate toward more subdued, less eye-catching, and more practical tones. However, special celebrations and good times mean brilliant colors for all. A celebration in Mali is something to behold. The Bambara are dancing and having a wonderful time—all in a sea of color! Every color you can imagine is on display. And the wealthy women may leave to change their colorful garb as many as five times during the course of the day's festivities.

● ● ●

The striking differences between the Tuareq and the Bambara represent, of course, two polar extremes when it comes to color. The point of using them as illustrations is to show that Africa is such a variegated continent we cannot just make assumptions about common color usage there. If one is traveling to Africa, the key questions are where are you going, and with whom will you be interacting. Only then can one get a sense of the customary Place Palette.

ASIA/THE FAR EAST

When we think of Oriental design and colors, we think of serenity and simplicity. Mellow, understated colors and warm, earthy tones. We envision soft wood tones, usually with a yellow base, soft blacks, tinted whites and cream, indigo blue, metallic brass and gold, the reds of lacquer ware, the green of bamboo leaves, and the pink of cherry blossoms.

Yet, here too, there is a wide range of what is acceptable and customary in color usage. We find that a country like Japan, which has been open to the world for many years, uses color differently than China, whose society is just starting to open up and become subject to outside influences. A look beneath the surface provides us with a picture that is an amaz-

112

ing combination of old traditions and an embracing of the outside world.

Japan is a country with a well-developed sense of design and color. For centuries the Japanese have maintained many traditions regarding color use.

For women, different colors are considered appropriate for wearing at different ages. The young, unmarried woman will wear soft pastels, such as pink, peach, and cream. Older, married women tend to wear black and beige. In fact, women a few generations ago would wear black kimonos when they wed.

Status and power is sometimes also conveyed via color. In the novel *Memoirs of a Geisha,* author Arthur Golden mentions the change in color used in the collar. This change is called "turning the collar." An apprentice geisha wears a red collar, and a geisha a white one. This small shift was understood by everyone to signify a major change in station and earning potential.

The Japanese also have certain colors that are specific to occasions. Black is the appropriate color for adult women at formal occasions. During a recent trip to Kyoto, I saw several bridal parties in the hotel where we were staying. The aunts, mothers, and grandmother were always in black kimonos with a beige design on the bottom. (An all-black kimono

with the family crest would have been appropriate for funerals, but not weddings.) As for the bride—nowadays, she is always in white.

Red and white, the colors of the Japanese flag, mean happiness and good luck and are used in many celebrations. Napkins or souvenirs given to guests at a wedding are often in red (or pink) and white. These colors are often used in decorations for other special events, such as office openings. In the old days, when carpenters would start to build a new house, the family would put into the construction area a package containing a rice cake and money for good luck, wrapped in red-and-white fabric.

Purple was traditionally the color reserved for the Imperial family—usually a soft, grayed-off shade of lavender. The color was not necessarily worn by the Imperial family, but rather used at public occasions to symbolize the dynasty.

The use of color was traditionally changed seasonally. A black kimono would never have been worn in summer except for a wedding or funeral. When the temperature was hot, the Japanese believed it was a woman's obligation as a hostess to wear clothing that made her guests feel cool, such as gray, ivory, and beige for older women, and light pink or light blue for young girls.

The use of seasonal colors was important not just in apparel, but in household decorative accessories. Once again, because guests should feel cool in summer, they were surrounded by and served with items in cool blues and greens. Because one wanted guests to feel warm in the autumn and winter, the colors used included brown and red (for camellias, which bloom in the winter). Soft colors were used for spring—the time of cherry blossoms and fresh green sprigs.

Kaiseki, the Japanese formal multicourse dinner, derives its traditions from the tea ceremony in which chinaware is changed to be appropriate for the season. Equally as important, each dish that is used for every small course should be suited to the food in shape and color. In times past, each small course of Kaiseki was served separately to each of the guests in attendance. The diners looked at the beauty of each course and admired it alone, not in conjunction with everything else being served. Today, Kaiseki is served with several courses on the same tray, and as a result the color aesthetic for each course is still important, but the color coordination among all the dishes on each tray is unimportant.

Today, Japan is a country that looks outside itself. Many of its traditions are no longer so rigidly observed, and the people are generally more casual

about their use of color overall. The younger genera-
tion is being raised on colors much brighter than were
ever used in earlier generations. In fact, when *Sesame
Street* was first exported to Japan, it was an adjust-
ment for Japanese kids to get used to so many com-
peting bold hues. (Being kids, however, they did
adjust—and quickly.)

The major change in Japan's use of colors has
been the embracing of Western Color-Forward col-
ors. Japanese women most often look to France, the
United States, and Italy for the latest fashions and
colors. Another recent change is the acceptance of
black in clothing for younger people, especially in
casual wear. While some women, especially older
ones or women participating in traditional activities
such as the formal tea ceremony, continue to follow
the old customs, many more dress in the same up-
and-coming colors used by trendsetting women round
the world.

So, if you are going to visit Japan and wish to fit
in, it is important to know not just where you are
going but what you will be doing and with whom you
will be dealing.

China is a country that is just inching its way from
traditional to more flexible uses of color. The Chinese

can, happily, leave behind the gray unisex suits of the Mao period as well as the dark blue caps and suits of the Cultural Revolution. These are examples of a repressive society using color as one of many ways to control people.

The Communist period aside, we find some similarities with other countries in terms of color use, and some striking differences as well, in terms of color traditions. The Chinese reserve a color especially for use in funerals, but in China that color was not black, but white. Most of the family mourners wear white. The flowers are usually white, occasionally yellow. Red is the color for weddings. The bride will wear a heavily ornamented red silk gown, comprised of a long-sleeved top and long skirt, embroidered all over, primarily in gold, but also integrating other bright colors in the design. The invitations are gold printed on a red card and sent in red envelopes. All of the guests will "sign in" on arrival at a wedding party on a huge sheet of red paper flecked with gold.

In China, as in Japan, color can have superstitious meaning and is often teamed up with specific flowers to bring good fortune. Pink, red, and burgundy peonies, often featured in Chinese water colors, signify good luck, good health, and prosperity. Red teamed with pink is the traditional favorite for the

Chinese New Year. The pink may be either a hot pink or the soft shades of plum and peach blossoms.

There's no doubt a visit to China fifteen years ago would have been a very dull experience in terms of color. That is no longer the case. Affluence and increased exposure to the outside world has brought a new awareness of the rest of the world, its color and its color directions. The first place that color appeared was in children's clothing. Now Color-Forward colors may be seen in China, especially among the younger people. Shanghai, known as the Paris of the East before the revolution, is fast regaining its importance as China's trendsetting city. At a recent fashion show in Shanghai that featured garments by young local designers for their domestic market, the colors shown were quite similar to the current Western directions.

However, in one key regard, the mainstream Chinese perception of color varies from ours. The Chinese like their colors bright, the brighter the better. (The aforementioned red and hot pink combination is but one striking example.) In fact, several years ago, it was difficult to sell Chinese products in the United States because they had not yet adapted the colors of their exports to suit American taste.

We cannot end our discussion of China without a mention of *feng shui,* the ancient art used to arrange

homes and offices. It embraces a system based on Chinese astrology that includes five elements—wood, fire, metal, earth, and water. Using its guidelines, one is said to be able to activate the invisible but powerful energies of the natural environment to bring good luck, guard against illness, and even prevent missed opportunities. Not surprisingly, *feng shui* also incorporates color. Its practitioners use its methods to determine a person's personal colors and use those colors to balance the energy of that person's space and bring it into harmony.

Feng shui is quite complex, and we could not possibly explain it fully here. But its increasing popularity in recent years has created a plethora of good books on the subject, which can be found at any library or bookstore. There are also practitioners who will help you apply *feng shui* to your special spaces.

ENGLAND

England is a country that for many years influenced the rest of the world, first through its empire and then its commonwealth. Of course, while it was influencing the world it was also being influenced by the color palettes of other cultures, including China, India, Africa, and America. To visually browse through

England's history—its clothing, furniture, and home decor—is to progressively glimpse bits of color from around the globe. Yet, after centuries of openness, England is still fundamentally traditional—a land of formality (think Queen Anne and Chippendale) and country casual (think Laura Ashley).

Today in England there is a renewal of period looks with authentic colors. A trip through Spencer House in London, for example, is a trip back to the hues of the eighteenth century. To capitalize on this popular trend, there are paint companies that actually specialize in colors for interiors that are accurate for Georgian-, Victorian-, and Edwardian-style homes. A company called Papers and Print provides products in authentic colors for interiors, and even for front doors.

The colors generally favored for dress in England are of a sedate and muted palette (again, think Laura Ashley). The heavy reliance on navy blue, grays, browns, and beiges are surely the result of England's overcast climate. If you are going for a traditional look in a car color, you'll surely want British racing green (think Jaguar). Red Ferraris might raise eyebrows here!

Of course, you will not be shocked to learn, however, that the younger generation in England often likes to break the mold and move into bold and Color-Forward hues. In the 1960's, the colors of Carnaby

Street were anything but sedate. Several years ago, along came the textiles of Tricia Guild, a British designer whose bright and saturated fabrics are a cinch to spot in showrooms. Just as there will always be an England, there will certainly always be those who like to stir it up.

FRANCE

The colors of France, at least in the southern provinces, are the antithesis of muted English tones. The extraordinary light in Provence and the Cote d'Azur that inspired the Impressionists still inspire people to use a myriad of bright, saturated, bold colors. But, interestingly, the Place Palette changes when one gets to Paris.

When we think of Paris we think of it as the center of fashion, the source of new styles and new colors. To understand why, we must go back to the era of Louis XIV. To protect his throne, he decided he would keep the nobles busy and out of mischief by forcing them to spend much of their time at the court of Versailles. Further, he made dressing stylishly of utmost importance, so they became "slaves of fashion."

Today, Paris still has its own rules. And one of them is that, regardless of the fact that Parisian cou-

turiers never fail to show the newest Color-Forward palette, fashionable Parisian women tend not to wear those new hues. Indeed, since Chanel and her "little black dress," black has remained the dominant color of apparel in Paris. The sophisticated urban women will wear a good deal of black, and sometimes move to other neutrals, but rarely to a wide array of colors. So pack accordingly!

ITALY

Recently I attended a party where I spoke with a woman who had just come back from Italy. She told me she had gone "shoe mad," purchasing shoes in virtually every color she could find—and she found a lot of colors. She was thrilled, because she found it hard to buy shoes here at home in anything but neutral shades. "In Italy, they're not afraid of color," she said. And, of course, she is right.

Indeed, like the south of France, Italy proudly partakes of the bold Mediterranean Place Palette. The light and the warm climate naturally contribute to Italy's penchant for bright hues. But one should also take into account Italy's hearty and robust cuisine and the passionate, vital temperament of Italians themselves. And, as a tour of the Vatican—with its

opulent golds, purples, and deep reds—will convince anyone, even Catholicism contributes to the richness of the colors used in this country.

If you are packing for Italy, pack colorfully. Or, as my acquaintance did, pack light and enjoy the shopping once you get there.

GERMANY

A friend of ours who frequently travels to Germany on business said he felt oppressed by many of its color schemes when he first began visiting. But gradually he changed his mind and understood what he called the "organic" nature of that country's most often used colors. Indeed, the weather, the natural environment of the countryside—with its preponderance of forest greens and dark browns—and the prevailing light conditions all contribute to a Place Palette of somewhat somber earth tones.

The heavy emphasis on green and brown tones does grow on one as one spends time there. And here's some more good news: When the Germans do decide to break their own mold and aim to startle with color, they *really* go for it. To walk through the Frankfurt airport is to be almost overwhelmed by bold primary hues.

The lesson: If you want to catch a German's attention and say, "Hey, here's something different," color is an easy way to do it.

SCANDINAVIA

The residents of Norway, Sweden, Denmark, and Finland spend much of their time immersed in darkness because of their extreme northern latitude. In this part of the world, color is often used to compensate for the lighting deficit. The light and bright Place Palette of Scandinavia is also a physical reflection of the Nordic people themselves, with their pale skin, blond hair, and blue eyes.

A look at the flag of Sweden—with its vibrant yellow cross on a brilliant blue background—will give you an idea of just how bright one may go in terms of color use and still be within the norm. Almost without exception you can expect to see beech, ash, and bleached oak.

THE UNITED STATES

With all this gadding about the world, you might feel a bit homesick. But if one longed for the colors of America, exactly what would you long for?

We have the advantage of having a population

who came from all parts of the globe, bringing both their color traditions and their willingness to try new things. Our clothing, fabric, home furnishings, and all kinds of other items incorporate African, Far Eastern, Mediterranean, and Victorian colors, and everything else that catches our fancy.

When we look at quilts, the quintessential American craft—and very popular right now—we get a sense of how American color dynamics work. We still love all the traditional patterns and colors—the log cabin with a red square for the hearth chimney, for example. And fabrics available for quilting often reproduce the patterns and colors from periods throughout American history (e.g,. the Civil War Era and the Roaring Twenties). But popular fabric collections from Japan and collections using the exotic colors from places as far-flung as East Africa and Bali are also available. Books on the art of quilting (some of my favorites are *Color Confidence for Quilters* by Jinny Beyers and *Liberated Quiltmaking* by Gwen Marston) encourage readers to choose colors freely and experiment with combinations. Such attitudes and openness are why the American Place Palette itself is like a multicolored quilt.

As we know, Americans as a group respond to certain color signals so predictably that color can be used

as a phenomenally effective marketing tool. We also make across-the-board color associations with certain of our holidays and rituals—black and orange for Halloween, red for Valentine's Day, green for St. Patrick's Day. However, there are some important regional variations in the way we use color in our geographically vast land.

We haven't conquered nature yet, and most of us have given up trying. So those of us who live in warmer climates wear lighter colors, and those of us who live in cooler climates wear darker ones. In case you're not sure about this, watch people at the Phoenix airport in January and February. You can tell who is coming in from Chicago, New York, or Boston for a visit, as opposed to those returning home, by wardrobe alone.

Likewise, if you visit places like Santa Fe and Taos—where the breathtaking light and colors of the New Mexican desert have for over a century attracted American artists in the same way that the south of France attracted Impressionists—you will see bright colors combined with earth tones (e.g., turquoise and terra-cotta) used in clothing and in home decor. If you visit New England, on the other hand, you will find darker, cozier colors, the sort

you'd like to have on a blanket wrapped around you on a frosty winter's day.

Of course, you will not be arrested by the Color Police if you build, say, a house in Nantucket and choose to decorate it Santa Fe style. Though your choice may not be commonplace, you'll be accorded the freedom of doing what you like with color. Indeed, more and more so, Americans—especially the younger generation and aging baby boomers—are casting old color taboos aside.

Despite what your mother may have told you, you *can* wear white after Labor Day if you feel like it. You need *not* necessarily wear only black to a funeral, but you *can* wear it to a wedding. If you like, you can even dress your small children in black—as opposed to soft pastels. As for color coordination, we all now have tremendous latitude when it comes to deciding what "goes" with what else. Just as a quilt whose colors coordinate perfectly can be perfectly boring, we have come to realize that the same principle holds true for anything. Accordingly, we have become more sophisticated, more receptive, and more courageous. With regard to color combinations, many of us enjoy the kind of subtle surprise that makes a good design more interesting and alive.

One final aspect of color use in America is that,
like most everything else in our culture, it is never,
ever staid. Back in 1992, I was interviewed by a radio
talk show host who proudly told me his wife had just
redone their whole house in mauve and dusty slate
blue. My reply was that he should start saving money
immediately because soon she would be ready for a
change—probably to hunter green or sunflower yel-
low.

What does this say about us? It says that in this
country most of us believe that the future will be bet-
ter. Fundamentally a nation of optimists, most of us
are open and even eager to see—and some very
quickly to try—what is on the horizon.

So just what is on our color horizon now?

SEVEN

The Future of Color

Though many color signals and color preferences are constants, there is an aspect of color that is ever-changing. Anyone who has not been on a cave retreat for the past several decades is aware that in any given season some colors are "out" and some colors are "in." But what most people don't know is how this gets to be so.

When I speak in public, people want to know what the newest color trends will be. But they also invariably ask: Where do the new colors come from? and Why do so many items appear in the same color at the same time? (The implication of the last question being: Is there a conspiracy?)

In this chapter I am going to take my customary climb out on a limb to predict the latest up-and-coming colors. But first I want to address these other

fascinating questions, which fall under the rubric called "color forecasting."

WHERE DO THE NEW COLORS COME FROM?

First of all let me say there is no evil conspiracy when it comes to color choices. Believe me, if sinister undercover types were meeting in windowless rooms five levels below ground dictating that, regardless of whether you like it or not, you will wear puce next year, I would tell you—even if it meant risking my own life. But, alas, the truth is nothing quite so cloak-and-dagger.

Admittedly, new colors arise from the efforts of professional color forecasters and designers to create what they believe will appeal to the buying public. These marketers and designers work in conjunction with the many companies who are eager to sell products and who know that color is one of the most important factors influencing consumer choices. (Yes, we shop for price and quality, but if the color is "wrong" we may well decide to buy from a competitor.)

But color forecasting is not about some elite group of self-appointed experts foisting colors on a public powerless to resist. Ultimately, the public rules, giving the final thumbs-up or thumbs-down. Success in

the marketplace is determined, quite simply, by what sells. And if we don't like it, we won't buy it.

Of course, as much as possible, businesses try to avoid mistakes because the cost of mistakes is enormous. They'd much rather get their colors right the first time than risk having to reduce prices on colored products. That's why they have come to rely on professional forecasting.

Color forecasting is part art, part science. Forecasters and designers don't just pull colors out of thin air. Rather, they look everywhere for subtle signs of whatever is already brewing on the cutting edge of popular culture. Their greatest tools are open, inquiring minds and a healthy sense of optimism. And because their goal is to select colors that will appeal, regardless of what they may personally favor, they must learn to put personal preferences aside.

Now I'll tell you a secret. Forecasters don't always bat a thousand. Those of us in forecasting know before we begin that we will predict some big winners, some colors that will do okay, and a few duds. (Purple sports utility vehicles anyone? I didn't think so, but someone did.) We work hard to keep a good winner-to-dud ratio—though there are probably easier ways to make a living.

Forecasting, of course, is difficult in any field. In

1996, in honor of its centennial, the Smithsonian published articles that had appeared in its 1896 magazine. One was by a man who had predicted we would one day fly from city to city. This was a truly radical, forward-looking prediction because we had no airports and the Wright Brothers had not even made their flight at Kitty Hawk. Then I turned the page to see the illustration that went with the prediction. It showed a man tethered to a hot air balloon. The "flight" consisted of a trip in a balloon pulled by a mule from one city to another!

In the forecasting realm, a miss is as good as a mile. To minimize the risk of being close but not close enough, we must be diligent observers. But where are some of the best places to get a whiff of the future?

Color Clues

One place the professionals go for hints of color trends and directions are trade shows, which are a wonderful source of ideas. For those of you who have never been to one, trade shows are gatherings of exhibitors—usually manufacturers—who display their latest and soon-to-be-released offerings. Open only to "the trade" (meaning those who work in a particular industry, and members of the press who cover that industry), these

shows are targeted to buyers who will come to see
what the market has to offer and what competitors are
doing, as well as to make purchasing commitments.

Virtually every product category has trade shows,
and some have several every year—local, regional,
national, and even international. But not every trade
show is known for showcasing colors on the cutting
edge. Among those that are known for doing so are
Heimtextil in Frankfurt, Germany, and the Inter-
national Housewares Show and the Gourmet Show,
both in the United States. In addition, the Auto
Show—exceptional in that it is open to the public and
held each year in several major American cities—is an
important source of innovative ideas on color and
especially new or unusual applications of finishes.

I attend these events regularly, and sometimes I
see a color I've never seen before. But just because I
see a color at these shows is no guarantee it will
come to market in the near future. Sometimes
exhibitors have colors on display as trial balloons to
see if anyone likes them. If no one chooses them,
they will never be manufactured. Likewise, forecast-
ers must keep abreast of the colors that are shown
each season at the Paris fashion shows. But there
may be colors shown there that will not appear in the
American market for years, if ever.

Forecasting may be tricky, but it is also a great deal of fun. And if you want to try your hand at it, whether to gain a business advantage or simply for the fun of amazing your friends with your uncanny knowledge of what's "hot," you can do so—and without traipsing all over the world to trade shows either.

Here are some of the things that professional forecasters, including myself, do routinely that you can easily do as well:

- Usually the trendiest stores are in major cities and areas that cater to young urban shoppers. They may be clothing stores, home furnishing and decorative accessories stores, fragrance emporiums, and the like. Forecasters shop the trendiest retailers, constantly on the lookout for new businesses that offer a different approach to color.

- Areas that are frequently shopped by the pros include SoHo in New York City, Armitage and Halsted in Chicago, Melrose in Los Angeles, and the Boulevard Saint Germain on the Left Bank in Paris. But the world is getting smaller and communication faster. So if you want to see the newest things, you don't necessarily have to

become a member of the jet set and journey to
New York or Paris.

- Believe it or not, you can get a good sense of
 what's up and coming just about anywhere by
 visiting chain stores such as Pottery Barn, Crate
 and Barrel, Calico Corners—and even Kmart
 and Target. And even if you live in a log cabin in
 the Rockies, you can learn a lot by perusing the
 catalogs of mail order merchants like J. Jill and
 Coldwater Creek.

- If you are visiting a resort area, it may also be a
 good venue for ferreting out the new Color-
 Forward hues. Aspen, Santa Fe, and the
 Hamptons on Long Island have long been
 known as trendsetter locales. But in the United
 States we have so many pockets of arts and
 crafts—Asheville, North Carolina, northern
 Michigan, and Seattle, to name a few—and
 visiting regional shops and craftsmen in such
 areas can also be very worthwhile.

- Another way you can scope out new colors is to
 look at certain magazines. One of my favorites
 for the cutting edge is *Wired*. This magazine for
 technology lovers uses the latest colors and

finishes on its covers. Another magazine to canvas is *Metropolitan Home*. Still another of my favorites is the French magazine *Côte Sud* available at newsstands that offer foreign publications. This magazine, whose title translates as "South Coast," is the most beautiful magazine I have seen for colors in home fashions. Because it specializes in the colors of the south of France and other parts of the world where the light is extraordinary, it shows a breathtaking array of hues that include some Color-Forward delights. My French is very limited. But even if yours is nonexistent, don't worry: the pictures speak for themselves. If you are traveling to any other country, it's always fun and informative to buy a fashion or home magazine. They provide a wonderful insight into that country's sense of color, as well as possible future trends in the United States. If you're not traveling abroad, most major cities in the United States have newsstands that offer a wide selection of home and fashion publications from France, England, Italy, and even Australia.

- Certain products—Color-Forward products—move into new colors faster than the rest. These

are worth paying attention to and are always fun to shop. Gift wrap departments, which I love to visit, are excellent places to see new colors and colored textures (just when I had perfected crinkle-tie bows, they came out with wired ribbon in beautiful new colors—some with iridescents or a hand-dyed look). Cosmetics also move toward new shades ahead of the pack. Ditto for decorative accessories like silk flowers and candles. Be sure to look at clothing accessories as well, especially the scarves of leading designers such as Ferragamo, which tend to use the latest colors. Yes, they're very expensive, but you don't have to buy to get ideas.

- Keep track of and patronize museum exhibits. Designers are often influenced by colors they see in an art exhibit. Vincent Van Gogh's paintings and Charles Eames's modern furniture have recently been featured in exhibits touring around the country. Because many designers will attend these shows, we anticipate increased popularity in yellows and oranges from Van Gogh, and black and chrome from Eames.

- Be aware of what geographical areas are capturing the popular imagination. Recently we've seen the Mediterranean, the American Southwest, and the Far East wield great influence on our color choices. Once the Far East became popular, we became interested in Eastern religions, movies about Tibet, Eastern music, and Asian food, as well as Eastern designs in home furnishings and apparel— including bamboo and wood prints, celadon, and red lacquer ware.

- If you are a moviegoer you are already one up, since movies often have a strong influence on what colors we favor. Shortly after the movie *Titanic* came out, a friend of mine who designs silk flowers was asked to "supply the kind of flowers they would have had on the *Titanic*." Movie special effects (such as those in *Star Wars*) also influence up-and-coming colors. And so do popular TV shows, especially those that appeal to the young, such as shows on MTV.

- If you know a bit about technology, that will also provide you with color clues. Technological developments also inspire designers because

they allow them to do what could not be done before. The development of pearlescent finishes in the early 1980's, for example, spawned a range of products from wallpaper to children's stickers to gift wrappings to automobile finishes. (Before this we had to rely on special effects produced by Mother Nature for these finishes, such as abalone and mother-of-pearl, which were not so widely available.)

- Even an awareness of social issues can give you an insight into color trends. Concern with the environment, for example, has led to widespread use of colors associated with earth-friendliness in clothing, architecture, automobiles, home products, and publishing, e.g., deep greens, ocean blues, earth tones, and the "unbleached" look.

Wherever you are looking, and whatever you are looking at, the trick is to keep an open mind. If something appears "outrageous" to you, don't dismiss it out of hand. My daughter's college roommate, Jodie, was in Paris in 1988. She saw backpacks, jackets, and activewear, all in hunter green and purple. The green-and-purple combination struck her as so odd it became a running joke about those crazy Parisians

and their strange color sense. But not too long after, such a combination became commonplace, and it no longer seemed odd to her at all. So *do* dare to imagine.

If you are a Color-Forward person, new colors will fill you with adrenaline and provide you with inspiration of your own. But even if you are Color-Prudent or Color-Loyal, by keeping an eye on color trends you can gain the courage to have a little fun—and get a new kind of reaction—with color. You certainly don't have to overcommit yourself financially or aesthetically to do so. Try new colors in small touches, especially on items such as gift wrap, flower centerpieces, candles, soaps, and napkins, which are inexpensive and short-lived. Likewise you needn't break the bank or suffer an anxiety attack to experiment with the latest colors on costume jewelry, colored designs on T-shirts, or ties and socks for men. If you are hesitant to try, say, a new upholstery fabric in an up-and-coming color, try doing what I did. I bought a bedspread in a new shade (from the Martha Stewart collection at Kmart) and used it as a tablecloth.

CRITICAL MASS

But let's get back to the "conspiracy" of professional color people. If you become an observer of color

trends, you will notice that colors that appear in an early-mover category of products—say cosmetics or scarves—are likely to show up before long in other categories.

It may seem to be happening all at once, but it is actually a gradual progression. Still and all, it is true that each year certain new colors reach a kind of critical mass. This happens when enough professionals see a "new" color, believe it has sales potential, and add it to their product lines. All at once a color appears, seemingly everywhere.

This is when we hear cries of "conspiracy." But it's really just the result of research and Color Smart business practices. Manufacturers in every industry want to know what's up in regard to color and since they don't all have their own full-time color snoops on staff, they buy color forecast palettes from full-time professionals who attend all the key shows, shop all the key retailers, scan all the key publications, and so on.

There are many forecasting services. Some operate in Europe and some in the United States. Some are affiliated with particular industries, such as Cotton Inc. There are also some professional organizations devoted to color forecasting, and many manufacturers designate staff representatives to join these organizations, attend meetings, and share information.

One of these forecasting organizations is the Color Marketing Group (CMG). CMG began informally in the late 1950's, when a group of paint and dye manufacturers who recognized the link between color and consumerism formed something called the Inter-Society Color Council. In 1962, the Color Marketing Group was officially formed, and it has grown steadily since then. Current membership, which exceeds 1,500, includes marketing and design professionals from a wide cross section of industries. The members meet twice a year—not to tell consumers what they *must* choose or wear, but to share information and observations and plan accordingly. Each year, when all its input has been received, the Color Marketing Group issues a forecast palette for two years in the future and makes it available to each of its members.

Another important group is the Color Association of the United States (CAUS), which operates under a different creative principle. Its forecast palettes, again done for two years out, are developed by a small group of experienced, premier designers who predict the colors for the category in which they work, e.g., women's apparel or interior home. CAUS offers each category's selections as a separate palette.

Our company, the Cooper Marketing Group, also offers forecasting services. In an effort to improve the

success rate in forecasting, we designed and conducted a nationwide consumer preference research study. That's because we believe that today's consumer is sophisticated about color, and that it is critical to include their reaction in any forecast.

Still think it's a conspiracy? Well, perhaps we can all agree there's a good bit of collaboration going on. But would you really want it any different?

In a *Time* magazine article, humorist Garry Trudeau recounted his visit to a CMG (which he called a "color cartel") meeting, noting how a series of caucuses results in an influential list of fifteen color directions that will appear a few years hence.

"Is this really necessary?" Trudeau asks. And then answers: "Probably. The human eye can distinguish roughly six million colors . . . I don't want six million color choices. I never have. Color is not a civil liberties issue with me. Maybe it's middle age talking, but in an increasingly fractious, decentralized world, I find it oddly comforting that somebody is in charge of color."

COLOR 2001

With that said, I hope you will feel neither conspired against nor dictated to when I tell you my own predictions for color in the year 2001 and beyond. But before

doing so, I want to put my predictions into context. You see, we can't get to where we're going until we're through with where we've been.

Remember the 1960's and 70's, when harvest gold, avocado, and burnt orange were everywhere? Some of us may remember only too well if we are still living with bathrooms or kitchen appliances in these colors. Today these hues seem to elicit a universal shudder.

Then came the 1980's, when we moved to products with a high-tech look. Some things went black, white, silver, and red—especially cars, which were strongly influenced by Japanese imports. Many other products, from carpeting to scissor handles—and our wardrobes—came in mauve and slate blue. You could stay in hotels as far apart as Boston, Los Angeles, and Honolulu and still be surrounded by these colors. Plumbing products and appliances came in "almond."

In the 1990's, in contrast to mauve and slate blue, came rich "jewel tones"—dark green, navy, burgundy, and deep teal. These looked fresh to us after years of grayed-down shades. From these jewel tones there emerged a clear winner—hunter green. It encapsulated much of what was important to us at that time in our culture. Remember, green reminds us of nature and brings the outside inside. It is also an upscale, rich-looking color. Last but not least, it seems durable.

At about the same time, yellow arose like a phoenix from the ashes. Throughout the 1980's yellow was dead. Then suddenly in the early 1990's a bright sunflower yellow became a runaway winner! For the first time since the 1970's we were buying yellows across many product categories. But some business decision makers, whose experience started with the 1980's, almost missed this major change in the palette. This was because they could not remember a time when yellow had sold. (One reason why it always helps to know your color history.)

The bright sunflower yellow was expanded into numerous other yellows—first, reddish yellow, then soft and creamy yellows. Designers started to use yellow as an accent in towels, linens, even wallpaper. It worked well as a contrast to the deep jewel tones.

But all the things we still owned in slate blue and mauve did not go well with yellow. So what could we do but replace them all and start over? It seemed imperative, because the more we saw yellow the more we liked it.

It didn't take long for designers to put yellow together with our traditional American favorite— blue. For marketers, combining blue with yellow can best be described as putting "rockets on rockets"— combining the traditionally best liked color with the

current favorite. This piggyback was a sure winner. We saw yellow and blue, often with white, on everything from Godiva chocolate boxes to bathing suits. And we loved it!

As yellow gained in popularity, it gained influence and affected all the other colors. We took those greens we liked and added yellow. (So for those of you who wonder where chartreuse came from, blame it on yellow.) We saw reds turning from mauve and burgundy to corals, clays, and terra-cottas. We even saw mustard yellow and olive green. But notice we did not see a reprise of the dreaded harvest gold and avocado.

By the end of the decade, yellow had affected virtually everything, including the colors of automobiles. Beige, taupe, khaki, and champagne cars are selling like ice cream on a hot summer day, and we are even seeing bright yellow cars.

In the 1990's we also saw purple become trendy. For the first time in my experience, purple had become a popular hue, used by more than the "closet purple lovers" who had always liked it but could rarely find it.

Purple was initially introduced as a "fun" color, an accent used with other colors. It was more or less expected to be a "flash in the pan." But it took hold and lasted for several years. The same was true of teal, which

both men and women took to and which became a major influence in everything from automobiles to casual clothes. We liked teal first in the deep jewel tones, but then later in brighter tones, and then pale tints.

At the end of the 1990's, in recognition of stress-filled days and our universal desire to slow down, designers gave us soft, relaxing pastel colors, known as "spa" colors—pale colors that often have a white undertone—and everyone, from Martha Stewart down to mere mortals such as you and me, embraced them. In came pink, pastel blue, creamy yellow, champagne beige, soft greens, and lavender.

In the 1990's, finishes became almost as significant as color changes themselves. Designers launched faux finishes that looked like natural surfaces and could be painted by amateurs. They gave us the brushed metal look (used on items from jewelry to doorknobs), iridescent colors (that Ford Mustang worth a higher price—up to $5,000 more—when it first came out), suede (used not just on shoes but paint finishes), and metallics. They showed us that a finish has the ability to change the look of a color.

This brings us at last to the 2000's. And we'd better hurry because the color winners are appearing even as this book is being finished.

In general, the complexity of colors will be impor-

tant. From the nineteenth-century Industrial Age up through the 1980's, we wanted products in flat, uniform color, because this was a sign of being machine-made, which we inferred meant good quality. But as we move into the new millennium we are now more appreciative of the beauty found in the natural environment. We notice and appreciate the nuances of complex finishes that enhance color variation.

We love variety more than ever. And more than ever, we shall have it.

So let's walk through the post-millennial palette color by color. We'll start with neutrals—colors that become basics in our wardrobe and home. As always, we'll use neutrals for large areas or things that we use frequently.

The first neutral we'll gravitate toward is gray. By 2001, gray will be soft and more complex than the old grays, which were flat and dull. Thanks to new technologies we will see grays with a subtle glimmer—a shimmering effect that will look innovative and sophisticated. We will see it in faux finishes that resemble natural materials, such as rocks and stones. Gray will also be important in richer metallic and iridescent finishes.

As yellow affected other colors, so will gray. Most significantly, we will have a soft, dusty violet—a continuation of the evolution of purple. We will see it

from pale to mid-tones to darks. We will also see our other favorite colors affected by gray, particularly teal.

Another important neutral group will be the golden neutrals—the yellow browns and yellow beiges, because we are not yet through with yellow. The primary yellow brown will be camel, but we will have darker leathery-looking yellow browns. We will see these shades in apparel, and even the ubiquitous white kitchen cabinets will be replaced with wood finishes in yellow brown and beige.

We're not through with greens yet either, but of course they will evolve—into soft mosses, deeper greens with a hint of yellow that remind us of forests. Khaki will continue to gain popularity. We'll see it more and more in automobiles, business apparel, and home furnishings. All of these colors will combine beautifully with the yellow browns, teals, and new violet.

Blue greens will continue to be with us—in a gray version, but also in saturated, bright tones that remind us of tiles in ancient Persia or old Indian turquoise jewelry. Again, these blue greens will not be flat, but will have the complexity we find in nature. They will include light and dark, bright and subtle.

Reds will certainly not disappear. We will continue our fascination with the yellow reds (coral and

clay) and the red oranges (though terra-cotta will be a bit brighter orange). We'll also add a new red. Not as bright as scarlet; it could be called garnet or cabernet. Some of the reds will deepen to cordovan leather. These reds will coordinate beautifully with the colors mentioned above.

We now have pastels and soft neutrals. Next will come bright shades in a wide array of colors—a reaction to years of black, black, and more black.

In general, color combinations will be new and refreshing. We'll see bold pairings such as bright Chinese red with Chinese export blue, soft yellow green with accents of bright chartreuse, or purple with red-violet outlined in a low-sheen gold on a white background.

With color, as with most things, the past is prologue, to be sure. But thank goodness for all the young, creative designers who are unintimidated by what's gone before. They offer us eye-catching looks that will add verve to our everyday lives.

And if that's some sort of a plot, I'm all for it.

Color Ad Infinitum

There is a joyful exuberance in a healthy mix of color. Few people would willingly live for long in a house decorated with one or two colors. After all, as you will recall, colors send far more positive signals than negative. Colors provide high points in life, spikes of excitement. The excitement of the new and the latest colors is particularly marked in the United States, for we are a nation of optimists. Color change to us is color progress. We see the new colors and feel a tingle, we buy them and feel a spark. We reshape our lives around them, making their energy our own.

But you needn't be Color-Forward to join the fun. Adding color is like celebrating a holiday, interrupting

the mundane cycle of life with something special. And as with the holidays, sometimes the oldies are the goodies.

All my life I have done needlework—sewing, knitting, embroidery, quilting—and for me the fun is in choosing colors. I love colors individually and figuring out how to bring them together. Lately, I have delighted in collaborating with one of my grown daughters and my daughter-in-law. Together we chose a combination of fabrics—Color-Forward, as it happens, for Noriko, Color-Prudent for Pam—that will match their china patterns. For us, as for so many people who do needlework, finding the right combination of colors, patterns, and fabrics makes for a real high—one that is only enhanced by being shared with family and friends.

Color is directly linked to health and well-being by many New Age practitioners. No doubt you have heard of the concept of "auras," color fields surrounding the human body, which some psychics claim they can sense. They maintain they can receive a wealth of diagnostic information about the state of a person's body and mind. In India, practitioners of Yoga have for millennia associated particular colors with each of the body's seven *chakras,* or energy centers. Medi-

tating on the color of a *chakra,* they say, can promote healing and balance.

Many believe in these practices; many more remain skeptical. But you need only accept that color and color combinations are capable of producing joy, and that joy and happiness produce well-being, to begin using color to bring excitement and energy, as well as peace and calm, to your daily existence. How? By adding varied colors to your world.

Variety is the key. We do our best in an environment that includes many colors—from active and energizing reds, yellows, and oranges to relaxing blues and greens. Yes, there are colors that each of us prefer—but overall there is not one magic color that makes us feel better than all the rest. We do best with a range that includes soft pastels, mid-tones, and darks—and some crisp, bright shades as well as subtle, grayed-down ones. Goldilocks liked her porridge neither too hot nor too cold. But where color is concerned, "just right" encompasses a range: warm, cool, spicy, bland—and once in a while, a shocker.

You now know how to use your newfound Color Smarts to do many different kinds of things. You can be a smarter shopper, a sharper seller, an athlete with a bit of an edge, a lover with a bit more allure, a par-

ent with a bit more to offer your developing child, a traveler with a bit more savvy. But also use your Color Smarts simply to enhance your own appreciation of life, to enjoy each moment and all it offers.

No matter what your customary palette, no matter what your longtime favorite hues, try letting a little more color into your life today. And see how much you look forward to trying even more tomorrow.